ITHACA

ITHACA

A BRIEF HISTORY

CAROL KAMMEN

Charleston London

THE
History
PRESS

Published by The History Press
Charleston, SC 29403
www.historypress.net

Copyright © 2008 by Carol Kammen
All rights reserved

First published 2008

Manufactured in the United States

ISBN 978.1.59629.515.5

Library of Congress Cataloging-in-Publication Data

Kammen, Carol, 1937-
Ithaca : a brief history / Carol Kammen.
p. cm.
ISBN 978-1-59629-515-5
1. Ithaca (N.Y.)--History. I. Title.
F129.I8K248 2008
974.7'71--dc22

2008038823

For Dele and Henny, the two wonderful women who have become my daughters, and for the women in Ithaca who talk, walk, read and lunch with me: Elizabeth, Joan, Karen, Lauris, Lizzy, Martha, Mary, Melissa, Miriam, Nina, Norma and Scobie.

CONTENTS

CONTENTS

ACKNOWLEDGEMENTS

I owe my greatest thanks to my husband, Michael, a true partner in this and in so many other things. I treasure his knowledge, judgment and patience. I am especially grateful to Robert Kibbee, curator of maps at Cornell University for his knowledge of local maps and permission to reproduce a number of them here, and to Howard Brentlinger and Nij Tontisirin Anantsuksomsri for scanning the images used throughout the book. Another important source of images was Bill Hecht, who has put much local material on the Internet.

I appreciate the support given to this project by Mayor Carolyn Peterson, Annie Sherman, Leslie Chatterton and Sue Kittel in City Hall. Many others have offered information: James Brown and Samantha Smith, Shawn Galbreath, Brett Bossard, Lenore Schwager, Ann Rider, Jennifer Streid-Mullen, Catherine Wedge, Jim Johnson, Deborah Dietrich, David Smith, Carman Hill, Dan Maas, Hunter Rawlings, Scott Heyman, Peggy Hill, Patricia Dunn, Robin Schwartz, Greg Trembly, Marcia Lynch, Nancy Schuler, Walter Lynn, John Marcham and Sharon Yntema. Also, I appreciate the aid of Laura Owens, of the Tompkins County Board of Elections, and Norma Manning, the Cayuga Heights village clerk.

I am very grateful to Raymond Wheaton and the Ithaca Veteran Volunteer Fireman's Association, which owns the Ithaca Fire Banner, for allowing me to reproduce it, and to Donna Eschenbrenner, of the History Center, who arranged for the scan.

Chris O'Connor conducted the research quoted in the text. Throughout, I have attempted to indicate the source of direct quotations, and I have cited the books upon which I have relied. The most important documents are the records kept by the Village and City of Ithaca, the *Ithaca Journal*, the *Ithaca Democrat* and personal memoirs. See also my books *Peopling of Tompkins County* (Interlaken, 1985), *What they Wrote: 19th Century Documents from Tompkins County, New York* (Ithaca, 1978) and *Cornell: Glorious to View* (Ithaca, 2003). Especially valuable are *Ithaca's Neighborhoods: The Rhine, The Hill, and The Goose Pasture* (Ithaca, 1988), edited by Carol U. Sisler, Margaret Hobbie and Jane Marsh Dieckmann; Daniel R. Snodderly's *Ithaca and Its Past* (Ithaca, 1982); Thomas W. Burns's *Initial Ithacans* (Ithaca, 1904); and Henry E. Abt's *Ithaca* (Ithaca, 1926). Other sources are named in the text. I have also relied on the state and federal censuses.

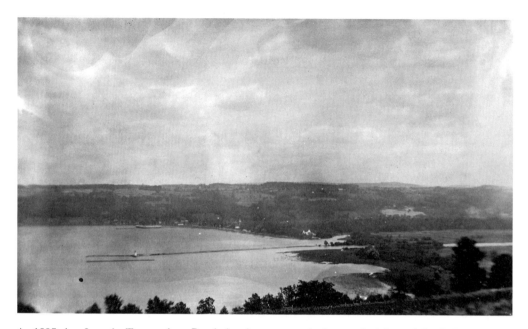

An 1897 view from the Trumansburg Road, showing swamps, the jetty at the inlet and the dock at Renwick Park. *Collection of the Tompkins County Historian 20.6.*

BEING AND BECOMING

On a Saturday in June, as I neared the far end of the Farmers' Market, the man from Littletree Nursery emerged from the side of his truck. He held cherries, both sour and sweet, in his outstretched hands. He sighed with a degree of awe and satisfaction and proclaimed to any- and everyone: "Welcome to another day in paradise."

There is the contradiction, the irony. In Ithaca, there is the sour amidst the sweet. We like to say that Ithaca is "ten square miles" set in the midst of reality; the lake and hills, cut through with deep streams, are stunning to behold, but Ithaca has also been prone to deadly flooding. In the same way, Ithaca's cultural offerings flourish, but its many performing groups are not particularly well funded. Ithaca is an educated community, but there is poverty of hope and ambition here, too. Ithaca's population is diverse, but there are racial tensions, and, over time, newcomers have not always been graciously welcomed. Ithaca is liberal, but those who think conservatively also live here. Ithaca is generous to its causes but had to learn to understand the needs to be found in its midst. Ithaca is organized, but perhaps over organized. Ithaca stands out politically and economically from the surrounding region; it has low unemployment, but also low wages for its educated workforce. Ithaca celebrates and promotes itself as a destination, but it has always been a "fluctuating place" with much coming and going. Ithacans complain about "the students," but those who come to learn here enliven our cultural lives, and education is our largest business. Ithaca has grown, but that growth in population has been slow and uneven. Ithaca is a small city divided into many different communities, with multitudes of opinions, groups and sentiments. Everyone in Ithaca has an opinion about just about everything. Ithaca might be said to be *in* the region of the Finger Lakes, but it is not quite representative of it. Ithaca stands apart. And it is "*so* Ithaca" to think so.

Ithaca's landscape was created by the activity of glaciers that carved out the lake and funneled water through Fall Creek, Cascadilla and Six Mile Creek. These streams cut through East Hill, leaving wedges of land like cake slices standing on a plate. This book cuts Ithaca's history into thirds. The first is the period of settlement through the anxious early years to 1870; the second, a time of organization and diversification leading through

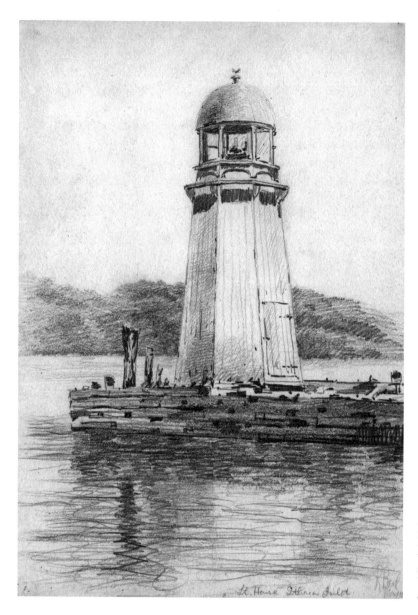

"Lt. House Ithaca Inlet," by Reynolds Beal, 1885, drawn when Beal was a student at Cornell University. *Collection of the author.*

the twentieth century to 1975; and the third, the past that was yesterday, which looks at our own time. Throughout, the topics that concern me are the things that shape life here: the landscape, government and our institutions of higher education. I am also interested in the growth of Ithaca's population and its diversity, our response to those in need and how we came to understand that not everyone is healthy, wealthy and wise. I am also concerned with the ways in which technology has changed life here, and how the rich cultural life we enjoy today came about. While much history is written in terms of forces and groups, in Ithaca we have also been shaped and enriched by individuals who have made a difference. The man at the Farmers' Market was wrong, of course, because this is not paradise, but, at the same time, he had it absolutely right.

"On the threshold of Ulysses"

The Odyssey

The Odyssey is the story of how Ulysses returned home to his Ithaca. This is a book about how Ithaca, which began tentatively, was part of Ulysses—a home to soldiers returned from war. In 1789, there was an exploration party here. By 1790, there were a few settlers, along with a storekeeper and a mill. But they were not the first inhabitants.

The land at the head of Cayuga Lake was swamp, beyond it was more promising, although the ground was covered with prickly bushes. In 1789, there were already some established fields, put in by the Tutelo or Sapony Indians who had come north from the Carolinas in 1753, fleeing from farmers who wanted their land and from Indian conflicts in which their small numbers put them at a disadvantage. They appealed to the Iroquois, who controlled much of what is today New York State, and the Cayuga nation allowed them to live as vassals along the Cayuga Lake inlet. The Tutelos built a palisaded village and cleared the land, living here until 1779, when, in the fall, with their crops in the fields, they were forced out by an army forty-five hundred strong.

In the midst of the war for American independence, George Washington ordered General John Sullivan to take action against the Iroquois. The army and the Indians met at the Battle of Newtown (near present-day Elmira), after which the Iroquois melted back across the land to Lake Ontario. The army advanced, burning villages and destroying crops, leaving the land uninhabitable for the coming winter. Turning back from the Genesee River, Sullivan dispatched two regiments, one under the command of Lieutenant Colonel Henry Dearborn, who traveled the east side of Cayuga Lake, and the other under Lieutenant Colonel William Butler, who marched along the west side of the lake. Each was ordered to burn and destroy crops and houses. They left devastation in their wake, including that of the Tutelo village of Coreorgonel, near present-day Route 13, south of Ithaca.

Through the lens of time, we can express distress about the tactics Washington adopted, concerns he hadn't the luxury to consider during that dreadful year when the outcome of the war with England was less than certain. Washington did not have the money or troops for a more significant target; going after the Iroquois, who were mostly allied with England, promised to be a less costly effort that might buoy the colonies. Sullivan did not accomplish any of Washington's goals, but the journey into Iroquoia fed the imaginations of the fighting farmers who looked hungrily upon the land. Nonetheless, when Dearborn and Butler rejoined Sullivan, the army marched out of our local history, and the Tutelos and Saponys were mostly gone.

The soldiers from New York had fought with the promise of payment in land, as the state lacked specie with which to pay them. The state suggested acres in the Adirondacks, which the soldiers rejected as too hilly and tree laden to make good farms. Then the state turned to the Iroquois land, clearing its title to New York State's satisfaction in a series of meetings with representatives of the tribes. The State of New York came to control its modern footprint. Before there could be a distribution, however, the land needed to be mapped, whereupon Governor George Clinton appointed his nephew, Simeon

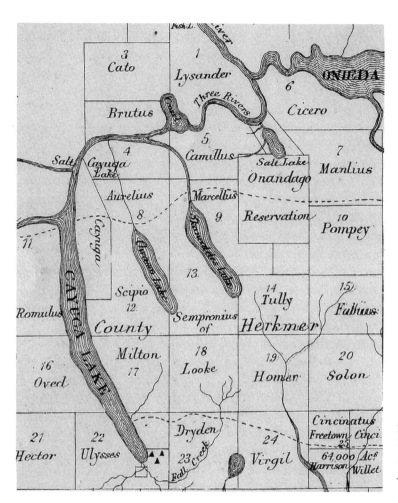

A Map of the Military Lands from *History of Tioga, Chemung, Tompkins & Schuyler Counties, New York* (Philadelphia, 1879).

DeWitt, to be his surveyor general. DeWitt and his crew set off into the wilderness. He identified the New Military Tract, made up of twenty-six towns, each with one hundred lots containing six hundred acres. On July 1, 1790, the state conducted a lottery in New York City for distribution of the bounty land.

Those who came first to Cayuga's shores had not waited for the lottery. They arrived looking for likely spots to settle. The early explorers sowed winter wheat, returning the following year with their families. The first three settled with their families at the base of Cascadilla Creek, near the "tuning fork" at the rise of East Hill, where there was a trail to Owego (today's East State Street). They had to contend with prickly scrub brush and mucky land, home to birds and infested with mosquitoes, poison ivy and rattlesnakes. They built cabins, a mill that produced twenty-five bushels of flour a day and expected to gain title to the land by sending an agent to Albany to pay state fees and return with proof of ownership. No one knows exactly what happened in Albany, but the agent defaulted, lost his way or may have been bribed. Whatever the reason, the early settlers lost their rights, receiving no benefit from their labors. In 1795, they moved elsewhere.

Dividing the Land

A veteran named Hendrick Laux drew Lot 94 in Town 22, fittingly named Ulysses for the Greek hero who wandered twenty years returning from the Trojan Wars. New York's veterans received their land grants more than seven years after the end of the Revolutionary War, by which time many of them had settled back into their old lives or had created new ones. For most, the land they received in 1790 was not highly regarded; many titles were traded for cash and even traded several times over for immediate gain. In a pattern familiar all over the Military Tract, Laux traded or sold Lot 94 to Jeremiah Van Rensselaer, who sold it to Robert McDowell. McDowell sold the central portion of the lot to Simeon DeWitt.

In Albany, at about the same time, Abraham Bloodgood received a grant of fourteen hundred acres that lay to the west of Lot 94. He, in turn, conveyed ownership of one thousand of those acres to Simeon DeWitt, who was related to him through marriage. DeWitt added to this by purchasing additional land from the southern end of Lot 94, along with several other portions, until his holdings totaled over fourteen hundred acres. He was familiar with the land at the head of Cayuga Lake because he had camped on East Hill when he mapped the area in 1796 for his large six-panel map of New York.

Detail of Simeon DeWitt's map of New York, 1802. This is the earliest appearance of the name "Ithaca" at the head of Cayuga Lake. *Collection of the author.*

An 1807 hand-drawn map of Simeon DeWitt's landholdings at the head of Cayuga Lake, from John Selkreg, *Landmarks of Tompkins County* (Syracuse, 1894).

When that map was published in 1802, he had already marked "Ithaca" at the head of the lake, within the Military Tract Town of Ulysses.

We do have to wonder about some of this: the land lost by the three early settlers needed to be registered in the office in Albany that DeWitt oversaw, and the land granted to his father-in-law was in the center of the flat area that DeWitt had viewed when conducting his survey. How he acquired the land cannot be proved, but why he wanted it is fairly certain, for looking from East Hill to the flats below he had seen the possibility of creating a city, a commercial center for the entire area, through which goods and people would flow. At a time when many men dreamed of farmland with fertility unknown in eastern New York, or manufacturing possibilities on streams through which water flowed or a resource in timber, DeWitt viewed the land differently. He pictured the lake as a conduit to the north and the valley to Owego as a transit to the markets of Philadelphia and Baltimore. He was a visionary, but he was also intent on making money, imposing order and attracting people to the new frontier. In the process of developing the land, the land took hold of him, and he returned to it almost every summer. He advertised the availability of lots for rent or sale. He created talk in New York City and Albany about Ithaca as a place of business. He offered parcels for eight to thirty dollars, slices set on narrow streets that intersected to create an urban center. Its locus first was on Aurora and Seneca streets. Gradually, the central core moved over to Owego and Tioga streets: today, it is the Ithaca Commons.

The oldest section of the cemetery, from *Ithaca Journal Centennial Number,* 1915.

Even with a promoter, Ithaca developed slowly. In 1800, there was a frame house near Cascadilla Creek and a merchant with a bag of goods for sale. In 1804, there was a postmaster. An exploring botanist named Preuss came to Ithaca Falls in 1806. He thought the falls were beautiful and tried to climb the hillside, but he found the going difficult, the underbrush too tangled to press through. On some Sundays, a Presbyterian supply minister came down from Trumansburg to conduct services, but not often, and not with any great effect.

H.C. Goodwin reported that in 1806 there were seventeen families living in twelve houses, six of them "frame buildings." A tavern opened in 1805, and DeWitt established a distillery. Horace King, in his 1847 published lecture *Early History of Ithaca*, reported that by 1808 there were thirty-eight houses, several mechanic shops, stores and a hotel. There was even a "respectable school house," a response to the state's encouragement that settlers initiate public education.

Nearby, there were other small settlements: Free Hollow, Pewtown, Shin Hollow (Trumansburg), Ludlowville, Dryden and Groton. The Watkins and Flint Tract, owned by land speculators in Connecticut, lay to the south. From it, they carved the towns of Caroline, Danby and Newfield. No other place had a proprietor and promoter such as Simeon DeWitt, and he proved to be essential to the development of the land at the head of the lake.

Ithaca was called "the Flats," "Sodom" and even "Sin City." This is true despite what H.C. Goodwin wrote in 1853, insisting on a tidier past. He stated that the early settlers of Ithaca "possessed no negative characters." He called them "men of activity and determination." Some probably were just that—men *and* women who had come west to succeed—but others among the earliest to arrive were most certainly not without undesirable qualities. DeWitt attempted to exert control over Ithaca by advertising for dependable settlers and by renting land rather than selling it so that he could judge how reliable and enterprising the newcomers were likely to be. He was not always prescient, however.

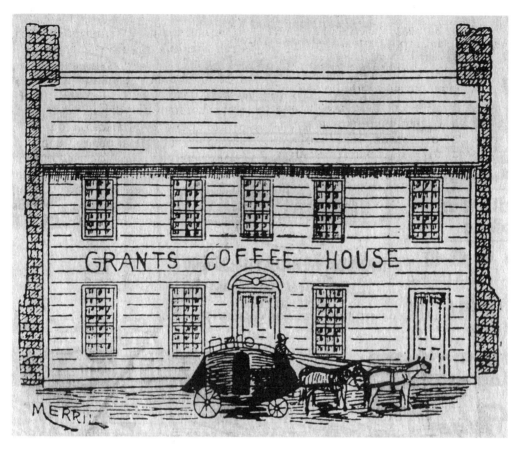

A drawing of Grant's Coffee House by Merrill, a nineteenth-century newspaper illustrator, from the *Ithaca Journal.*

In 1808, when Peleg Cheeseborough arrived, he remembered that he had heard Ithaca was an "enterprising place," and he had come down from Aurora to see for himself. What he found were a number of taverns, a blacksmith shop, a hotel and a mill. There were no roads west of the inlet, only two or three stores and he judged that the "town was one of the hardest possible and very commonly known as Sodom. Such an idea as temperance was unknown."

Not a great deal is known about the earliest settlers. Most were native-born Americans willing to take a chance on the frontier. By 1805, Simeon DeWitt had encouraged his cousin Gerrit Mandeville to move to Ithaca to minister to the small, leaderless Presbyterian congregation. He must have hoped that an established church would curb the wilder elements in the community. There were some upright people like Colonel and Mrs. Thayer, the first couple Mandeville married, who remembered Ithaca as an enterprising place. Both spoke of the first Independence Day celebration in 1809, when Colonel Thayer fired the initial salute, which was followed by an oration and prayer. The next day, everyone helped raise the frame of the Ithaca Hotel.

This is hardly enough cause for the names Ithaca was called. The Thayers remembered Ithaca's pioneer days selectively, without mentioning that a significant portion of the

community was made of up of transient teamsters. The passage of the Non-Importation Act by Congress, which prohibited trade outside the young nation's borders, was intended to encourage Americans to develop native manufactured goods and to find raw materials at home, rather than relying upon goods imported from abroad. In force, between 1808 and 1809, American raw materials were often located in inconvenient places and needed to be carted to market. Ithaca's location made it an ideal transshipment point between Salina, near Syracuse, where salt was mined, and buyers to the east and south. Salt, a heavy cargo, was transported from the curing beds by wagon to Cayuga Lake, where the wagons became barges as they slid into the water. Floated down the lake as a string of rafts, at Ithaca the barges were placed back onto wheels to complete their journey south. Necessary to this whole enterprise were coopers, wheel makers, general laborers and hundreds of mules and teamsters. These hardworking men arrived in Ithaca on the salt barges and waited there along the inlet to take the cargo south. So great was the amount of salt flowing out of Ithaca that, in 1810, private investors opened the Ithaca–Owego Turnpike to speed the wagons along, also providing an emigrant pathway to Ithaca. The turnpike company collected fees from users going north or south, in either direction, bringing new settlers into Ithaca and aiding in the settlement of the Watkins and Flint lands, through which the road cut.

Earning a Reputation

Ithaca's rambunctious reputation stemmed from these workmen arriving and departing with salt and the time between trips that was spent in local taverns. Ithaca had little to offer these men in the way of entertainment. DeWitt attempted to counter the fractious nature of life in Ithaca—and the sour reputation it fostered—because a rowdy community was unlikely to attract new residents or significant commercial activity. He wrote in 1810 that he felt "confident I should see Ithaca as important a place as Utica is now." It was a splendid location for trade, he insisted, and it had a "stir of business." There was an inn, a "respectable tavern"—obviously not one used by the teamsters—and a number of merchants, including shoemakers, tailors, a watch cleaner, a tuner, hatters and millers. There were also two lawyers and a doctor.

That same year, his cousin, DeWitt Clinton, visited Ithaca on his tour through the western part of the state to identify a route for what became the Erie Canal. Ithaca was obviously too far south to qualify, but Clinton thought Cayuga Lake would provide access to the canal, and he reported that there would soon be a road open to Geneva, now Route 96 to the north. He also wrote that land in Ithaca was selling for twenty and twenty-five dollars a lot, but that DeWitt had stopped sales "to see whether the conditions of improvement will be fulfilled." Ever watchful, Simeon DeWitt, a man with many useful relatives, sent his brother-in-law, William Linn, as his agent to monitor his Ithaca land and collect rents and fees. Clinton, too, commented on the "respectable tavern," which had just been renamed "Tompkins" for the state's new governor, Daniel Tompkins—a foresighted move, coming eight years before the state created Tompkins County.

A portrait of Reverend Samuel Parker. *Gift from Laura Holmberg, in collection of the author.*

Ithaca's commercial activity fueled the local economy, but it also created difficulties. The Reverend Samuel Parker wrote that

> *this influx of boatmen and teamsters, who were engaged in their work seven days in the week, with no intervening day of rest and very little if any religious influence exerted upon them, soon made the place as proverbial for its wickedness as it was for its rapid growth and the increase of its business facilities.*

Prim people like Colonel Thayer would have agreed with Reverend Parker, who played a significant role in opening the Pacific Northwest in the 1830s. Most settled Ithacans looked upon the transients as a population in need of control. But what were these men to do? Ithaca offered few unmarried women to court, and it is doubtful that these rough laborers would have been deemed acceptable by hovering parents. There was a gulf of difference between the culture and goals of the early settlers, many of whom were hardworking and religious—though certainly not all were so inclined—and those men whose work with barges, mules and wagons brought them into the area and then whisked them out again.

At the time, the young country was also at war with England. Fought between 1812 and 1814, with many of the battles on New York's western and northern borders, some Ithacans were drawn into service, frequently for a month or two. Congress's response to the war was to pass a second non-importation act, barring goods from England and Canada. Plaster was added to the list of raw materials passing through Ithaca, increasing the number of teamsters, according to some writers, to four hundred at a time.

The teamsters' presence required a delicate balance. The rowdy element was certainly not good for Ithaca's reputation; these transient men needed to be tamed in some way for in their free time, they drank, fought in the streets and frightened the horses. Yet, they were men from whom local tavern and innkeepers, as well as grocers, could extract money. Lacking any person of authority who might keep the peace, Ithacans created a committee called the Moral Society, a self-appointed group of vigilantes who monitored behavior and punished those who were most out of line, waiting just long enough so that money could be transferred from teamster pockets to line those of Ithaca's shopkeepers.

The Moral Society stepped in to stop bullies, boasters or anyone who wanted to entertain or "astonish" people with a puppet show or other feats of legerdemain intended to relieve Ithacans of a bit of money. The Moral Society would surprise its victim by placing him under a crate, where he could be drenched with water or entangled in a rope and dragged to the creek. A miscreant might be frightened into a race through the wild plum and hazel bushes that were "standing thickly and almost impenetrable, close by"—which tells us something interesting about the groundcover just off the rough-made street—or made to run a gauntlet of men who struck him or discharged firearms nearby. The vigilantes held trials, too, and directed their victims to leave town after paying a fine. The comic side to this nightly battle to clean up Ithaca's streets, and its reputation, was that even upstanding citizens sometimes found themselves in the village pound, along with the drunks, roaming cows, pigs and a goose or two.

All this looked promising to Jonathan Ingersoll, who came to Ithaca in 1815 with a printing press. He established the first newspaper. Other newcomers arrived, a subscription library was established and the Bank of Newburg, probably at DeWitt's urging, opened a branch office in Ithaca. The Reverend Mandeville, however, after ten years of attempting to bring religion to Ithaca, called it quits and left for the Town of Caroline, where he established a Dutch Reformed church and lived ever after.

"A Needy Place"

Ithaca had acquired a population of four hundred, but in 1816 it was called a "needy place" because of the "wickedness of its inhabitants." That year, Reverend Parker, minister of the Congregational Church in Danby, requested that his colleague, William Wisner of Elmira, relieve him from preaching one Sunday. When Ithacans heard that a supply preacher would be nearby—word must have passed from person to person—they asked Wisner to officiate at a service for them after completing his duties in Danby. Accordingly, Wisner preached in Danby and then rode on to Ithaca.

I see Wisner as a man in a wide hat, his jaw forward, setting off determined to save

even the most wicked. What he found in Ithaca was a congregation in disarray. There were "but one praying man and two or three pious females." There were twenty church members of whom "one was a Swedenborgian preacher and five were intemperate, and some others so grossly immoral that six of the male members and two females had to be cut off from the communion of God's people." There was a "corresponding state of things in the community without. Sabbath-breaking, gambling, horse-racing, profane swearing, drunkenness and licentiousness were fearfully common," wrote Reverend Parker. Wisner preached to those who remained, and they implored him to come to Ithaca, pledging a salary of $600 a year—a rather astonishing stipend for the times.

Ithaca provided Wisner with an ideal opportunity to confront the sinner. The community reaction to him, however, was mixed, and some in Ithaca took to calling East Hill, where Wisner had a house, "Brimstone Hill." A mob burned down the "respectable" schoolhouse in which his congregation met, and they covered Wisner's horse with wet plaster, which had to be hammered off. Some, most usually identified as local lawyers, conducted horse races in front of the barn to which the Sunday services moved. Wisner fought back with sermons warning of the wrath of God.

In Albany, DeWitt was at work trying to bolster his community. His hand must have been behind the 1817 proposal by the State of New York to create a new county and the suggestion that Ithaca become the county seat. Until this time, Ithaca had been an unincorporated hamlet within the Town of Ulysses, located within Seneca County. Lansing (then called Milton) and the towns of Groton and Dryden were in Cayuga County. A more logical county might have been one situated between the lakes, rather than one through which the lake plunged, creating a barrier between county parts. But no other community had a highly placed state official advocating its charms. Status as county seat would swell the population, increase the economy and establish public buildings. Ithaca would also achieve stability and importance as a unit of state government and seat of justice.

There was a catch, however. To earn this plum, Ithaca's residents would have to raise $7,000 to build a county courthouse and jail. Although Ithaca had a promoter, it did not have a benefactor. To raise this sum, the community would have to work together. Abruptly, the tug of war between the righteous and those who were not, the rowdy and the Moral Society, ceased. Rather than remaining sparring partners, they became, of necessity, allies, for everyone was suddenly a stakeholder. Wisner, called a "pugnacious divine of the old hell-fire school, a Puritan to the backbone," brought piety to the situation, working fervently on God's behalf, which was also to the benefit of the community. The Moral Society adapted to the new situation, and the canvas for funds began. Within a year's time, a small courthouse and jail were in place on East Mill (now Court) Street.

THE VILLAGE

County status ended Ithaca's boisterous adolescent phase. In five years, the population increased and diversified, and residents assumed control. No longer was Ithaca to respond only to Simeon DeWitt; now those who lived here began to shape Ithaca's future. Still,

Ithaca was considered "a most fluctuating place." People flowed in and then out again, a pattern that has been true throughout Ithaca's history. For example, Robert Maines, an African American, was the first barber in Ithaca. He advertised in 1821 in the newspapers, married and the couple had a child. The family was listed in the 1830 census. Then they disappear, only to reappear in Iowa in the 1860s. Not everyone remained permanently at their first stop on the frontier; many moved on.

In 1818, there were over six hundred residents in Ithaca. There were seventy-seven houses, four inns and nineteen stores. There were groceries, mechanics' shops and offices for lawyers and doctors. The Ithaca Steam Boat Company brought an engine from New Jersey, placed it on a hull built in the inlet and launched the *Enterprise* connecting Ithaca with the northern end of Cayuga Lake. The New York Methodist Episcopal Conference considered Ithaca a likely place for a college intended to educate both men and women. David Ayers started a subscription but was unable to collect enough money—or else the charms of Cazenovia proved greater—and the school was not built on Ithaca's East Hill. The money and donated building materials were used instead to create the Ithaca Academy, built on the "school lot" at the corner of Buffalo and Cayuga streets, to educate

Steam Boats on Cayuga Lake.—This little lake, though but about 40 miles long, and from one to four miles broad, is situated in the very heart of a great and flourishing state, and already has two steam boats, which, during the warm season, are handsomely encouraged. At the head of the lake stands Ithaca, a busy and growing village, of about 3,000 inhabitants. The scenery around is at once picturesque and inviting, and the climate is noticed for its salubrity and softness of temperature. The steam boat Enterprise will run every day from Ithaca to Cayuga Bridge, 38 miles—and the Telemachus, a new and fast boat, will, after the first of May, play as often between the two places. A stage runs from Montezuma to East Cayuga village, in connexion with the boats.

At Ithaca, the Waterfalls, which are easily accessible, and are to be made more so, are numerous, romantic and beautiful. The fall river descends a flight of rocky steps of 438 feet, within the distance of one mile. The great fall is 116 feet high, and the rocks adjacent are truly magnificent. The Cascadilla is also wild, varied and majestic in its course. The Six Mile Creek is equally romantic, and the Buttermilk falls are considered objects of great curiosity. Within a few miles of the village, at Goodwin's Point, the Taghcanic falls 262 feet perpendicularly into a ravine of wonderful formation. At Ithaca and its vicinity there are said to be no less than twenty falls of water, which are objects of interest to the curious traveller.

Bost. Trav.

A notice about Ithaca that appeared in the *Christian Mirror*, April 18, 1828. *Digital scan provided by Bill Hecht, 182/18263.*

boys and allow "female education." Even without the college, there was a nice hum of business fulfilling DeWitt's hope for the land.

A significant organizational change occurred in 1821, when the state separated thirty-one Military Tract lots from the Town of Ulysses to create the Town of Ithaca. Seventeen days later, responding to an application from residents, the state incorporated Ithaca as a village, recognizing its status as county seat and requiring it to form and manage its own government. The village boundaries, using today's street names, were Marshall Street as its northern line; the rise across East Hill, including Brimstone Hill, the eastern line; and Clinton Street its southern boundary. The village ended one mile from the eastern boundary in or at the inlet, an area so full of mire, vines and brambles that the surveyors refused to push through it to place markers. The land within the village had a number of owners, but Simeon DeWitt controlled the large central portion.

On May 8, 1821, an election named the first village president and five trustees who were empowered to raise $500 by tax the first year and no more than $400 per year thereafter. They were expected to erect public buildings, buy fire engines and make improvements, especially to the roads. A volunteer fire service provided some policing of

The Presbyterian meetinghouse, erected by the community in 1816, from *History of the Presbyterian Church* (Ithaca, 1904).

the streets: the Moral Society was no longer needed and became, for a time, little more than a social club before it disappeared entirely.

The major functions of village government were to maintain order and to control the forces unleashed by Ithaca's unique landscape. There was constant danger from fire and floods, and the need to provide transportation routes to, from and within the municipality. The earliest village laws prohibited pigs and other animals from running freely and fined anyone impeding or blocking public streets. Also forbidden was firing off a gun, "rocket, cracker, squib, or fireworks," flying a kite or playing ball in either of the main streets. Drivers were cautioned not to whip their horses faster than a trot, while racing horses on the village square (now DeWitt Park) was prohibited. There was a two-dollar fine for anyone undressing and bathing in Six Mile Creek. The trustees required all villagers to be prepared to fight fire by having a leather water bucket at the ready, as fire was the most costly of disasters and an ongoing problem. Of the $200 collected for village expenses, the president ended with a surplus of $87 at the end of the year.

In 1821, Ithaca's population numbered just over twelve hundred. It was the whole community that built the Presbyterian meetinghouse, and when complete, the congregation bought the parcel of land next to the church for a public park. There was a Methodist church, established in 1820, at the corner of Mill and Aurora streets, just beyond a grove of butternut trees, with a bell in its steeple—the first to ring out over Ithaca. It was also used to sound alarms, its clear tone floating over the flatland and onto the hills around. In 1821, Episcopalians left the Presbyterian Church to organize the St. John Episcopal Society. These defections from his congregation did not please Reverend Wisner, who preached "discourses attacking the doctrines and usages" of other denominations, though his own church grew so large in size that he even considered dividing it, although he never did.

Ithaca became a bustling community. The number of buildings increased by almost one hundred, and there were significant public buildings, including three churches, an academy, a fireproof county clerk's office, twenty-nine stores, including five millineries run by women, and two bookstores. There were fifty mechanics shops, a busy paper mill and three printing offices producing a newspaper and publishing books—some of which were printed elsewhere and given title pages and covers naming Ithaca as their place of origin. Other books, such as Lyman Cobb's *A Just Standard for Pronouncing the English Language* (1822) were printed in Ithaca.

DeWitt ought to have been pleased at the progress, and he was certainly enjoying the profits as his land increased in value. There were bookbinderies and goldsmiths, cabinetmakers, chair makers, wagon and carriage makers and workers of copper and tin. There was a stonecutter and one pottery. The value of Ithaca's exports in 1825 was $75,000; imports of manufactured goods of better quality, or not locally available, equaled $220,000. Salt, lime and plaster were shipped south; the plaster needed both for house construction and fertilizer. There was a brewery, and there were two distilleries in Ithaca.

Even though it was tamed, Ithaca had not lost its taste for alcohol. The trustees cited local grocers for selling alcohol without a license and threatened prosecution. They convinced taxpayers to add three acres to the city cemetery and had the area fenced. They also encouraged prosecution and fines for those who erected dams along Six Mile

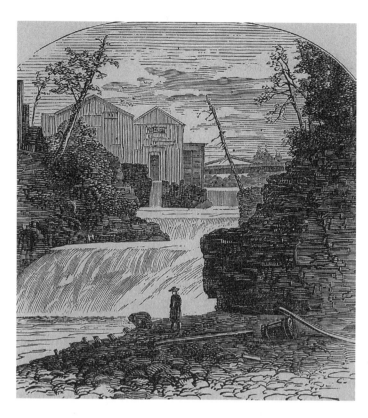

Six Mile Creek, showing a factory on the water's edge. This photo was taken by J.C. Burritt and published in *Scenery of Ithaca and the Headwaters of the Cayuga Lake* (Ithaca, 1866).

Creek, thereby blocking water flow downstream. Early village presidents "recognized the tendency of the village toward unsavory reputation," ascribing the causes to the rapid growth of the Erie Canal, opened in 1825, and the flourishing local brewery and liquor business.

Ithacans were divided, however, over the issue of alcohol. Those who did not imbibe supported temperance societies, of which there were at least five in 1820. The churches advocated temperance, men and women meeting in separate groups. Advocates of temperance, or even abstinence, aimed at preventing the "fall" of those addicted to drink; they hoped to reform the individual drinker, protect the family abandoned by drunkenness and protect taxpayers from the responsibility of supporting those who could not care for themselves. But the campaign to regulate liquor sales created a "tumult among the grocers and their tippling customers." This was a battle fought until the passage of the Eighteenth Amendment in 1919, and then caution regarding the use of alcohol rose again at the end of the twentieth century for safety, rather than for moral, reasons.

In 1826, Ithaca altered its charter and its borders. Until that year, Fall Creek was a discrete community, divided from Ithaca by a pathway through the swamp and counted separately in the census. The waterpower of Fall Creek fostered industry, beginning in 1814, when Phineas Bennett erected a gristmill with water running from the streambed through a wooden flume. In 1816, there was a chair factory using water from the falls, a sawmill and several gristmills. In 1817, there was a distillery and an oil mill. By 1819, there was a plaster mill and carding room. In the 1820s, a variety of industries flourished

as water turned gears, levers and millstones. All during these years, properties changed hands frequently, as one enterprise after another expanded or failed. In 1823, a report in the *American Journal* listed Fall Creek as "being without the corporation limits," a mile or so from the village with a population of 136, including 27 families working at mills, a furnace, a shoe shop and a gun factory. After 1826, Fall Creek, which never had any formal or even informal governmental structure, was incorporated into Ithaca.

BURNED-OVER

In 1826, a most unlikely series of events occurred in Ithaca. Considering the village's past, it is a surprise that religious revivalism broke out with such force. During the 1820s, there were episodes of intense religious enthusiasm throughout the state. Central New York came to be called the "Burned-Over District" because of its frequent outbreaks of religious fervor likened to burning wild fires, flaming up, tamping down and then erupting once again. Revivalist Charles Grandison Finney ignited the initial sparks, preaching in more than fifty central and western New York towns and eventually in New York City. Finney was something of a force of nature, prodding sinners to pray out their sins, conducting immediate conversions, stirring up communities with his doctrine of holiness and perfectionism and insisting that lives should be given completely over to God. Even where Finney did not go himself, his disciples and students went, engaging in dynamic preaching. The upstate response to Finney and other revivalists, those who preached millennial messages—and some crackpots—was immediate and intense. Why? Central New York has been described as an area where there was a high rate of elementary education (a literate but not necessarily sophisticated or discriminating population), an active and often hysterical press—all the better to sell newspapers and magazines—and, for some, lives that held few distractions aside from religion and an expectation that, in some way, they would prosper and be saved.

Welcomed in many localities, this avid turning to religion was probably least to be expected in Ithaca. Yet, ministers of the Presbyterian, Methodist and the newly forming Baptist congregations began a series of revival meetings in December 1825 that became a "momenteous time." Righteousness ran down "our streets like a River," S.J. Parker, son of Reverend Samuel Parker, wrote in his recollections of life in Ithaca. Young Parker remembered it as a time of "loud preaching" that could be heard from one corner of the village to another. "No one seeking religion then thought of creeping into the experience" but did so boldly and with family, friends and neighbors at hand. The numbers sound inflated, but he claimed, and others agreed, that "more than five hundred persons in the village have been converted." All three congregations were strengthened by the admission of new members, and attention to matters of faith was paid, "at every street corner." People from Pewtown and Free Hollow, in the Town of Ithaca, from Danby and outside the county came to Ithaca to hear the preaching that went on day and night. There were prayer meetings in different houses, and even in the courthouse, "to accommodate those that were anxious to attend." This was certainly not the Ithaca of alcoholic disputations and irreligion.

The outcome was an increase in the membership of the Presbyterian Church as fifty

people were "taken in" in one week. "The Baptists are also getting alive," noted Brother Perkins. "Our congregation has so increased that we cannot well accommodate them at all times," and among the Methodists, whose converts were "young men and women, and numbers of poor families [that] have lately come in here. So that we have the poor but we must be thankful for them." Perkins would have liked a few converts who were more able to fill collection plates. On the other hand, most of the converts, according to Perkins, were "very firm and resolute," so much so that he contemplated enlarging the size of the Methodist chapel by twenty-two feet. "Our society," wrote Perkins, "has increased so much that we now have fourteen [religious] classes, including one at Fall Creek," still viewed as separate from the Village of Ithaca because there were few buildings in the intermediate area, and Ithaca's streets had not yet been extended to the falls. These classes aided in intensifying the religious experience and kept those who converted in the emotion of the moment closely connected to the congregation to which they pledged themselves while in enthusiastic fervor. There was, among the churches, a competition for souls.

BLACK ITHACA

Among the Methodist classes was one held for the "welfare of the coloured people." Many of Ithaca's black residents had joined the Methodist Episcopal Church during the 1820s, their baptisms duly noted on the membership list. They attended a summertime revival in Lansing with the Methodists, even while white members of the congregation worried about the religious excess often associated with revivalism in the countryside. The black Methodists were cautioned to remain camped with the Ithaca Methodists, but somewhat apart from the others so that they would not be tainted by unseemly enthusiasm. In the end, however, David Ayers, the man who urged caution to his Methodist brethren, succumbed to the preaching and rolled on the ground in religious ecstasy, along with those worrisome country folk.

It was Ayers, a white man, who led weekly meetings among "these serious Africans." He instructed them in the tenets of his denomination and "assisted in the divine life." The African class began with nine members but soon grew to twenty, who "appeared to enjoy pure religion." The meetings became more and more "spiritual and profitable," so that soon Ayers and the Reverend Benjamin Sabin, who reported about these activities, could see "the little cloud that had sprinkled the poor Africans in their prayer-meetings, down toward the Inlet, rising over the village, and giving the sound of much rain." Still, as the numbers of black members increased, the Methodist Church fathers cautioned African American parishioners to sit quietly and in the back of the chapel.

Also transforming the lives of black Ithacans was the fact that slavery within the state was legislated to end in 1827. Daniel Tompkins, the governor, had signed the act into law in 1817, the same year this county was named for him, although he never visited here. The date of emancipation was July 4, 1827, a time for jubilation, yet its celebration also caused discussion and concern within the black community. Black leaders, especially those in New York City, were agitated about the most appropriate way to mark this

momentous day. So, too, were black elders in Ithaca.

African Americans had argued for freedom and equality of citizenship for many years, and each Fourth of July they felt the indignity of enslavement in a nation celebrating itself as a land of the free. The issue of how to celebrate in 1827 was widely debated. In New York City and Albany, black leaders acknowledged the need to show gratitude to God and to their public benefactors for ridding New York of slavery, but they commented that the "4th of July is the day that the National Independence of the country is recognized by the white citizens." After due consideration, black leaders announced that "we deem it proper to celebrate on the 5th."

This was also the decision in Ithaca. Black Ithacans, and many African Americans from around the county, stood aside as white Ithaca celebrated the Fourth of July, and then on the Fifth, blacks held their own very similar celebration. As with the celebration the day before, there was an emphasis upon order. The *Ithaca Chronicle* reported that, on the Fourth,

> *it affords us pleasure to say, that the happy day passed off, and a very large concourse peaceably dispersed, so far as our observation extended, without any of those scenes of dissipation and riot which have too frequently characterized its return.*

This comment reflects the past that the community was attempting to live down. The Fourth was, recorded the paper, a "gratifying exhibition of the sober virtue and intelligence of a free people." About the Fifth, much the same was reported, although the statement regarding order appeared at the top of the article and not at the end. The *Chronicle* stated that the black celebration was held in an *"exemplary* and orderly manner."

And so it was. The Ithaca celebration of emancipation on the Fifth of July 1827 began

ITHACA CHRONICLE.

·WEDNESDAY, JULY 11, 1827.

The *Farmers,* and *Friends of Domes-tic Manufactures,* in the county of Tompkins, are requested to attend a MEETING, at the Hotel in Ithaca, on *Saturday next,* at 3 o'clock in the afternoon, to take into consideration the propriety of being represented in the convention to be held on the subject of Domestic manufactures and home industry.

July 11, 1827.

FOURTH OF JULY.

In this village the recent national anniversary was ushered in by the firing of can-

this important period to them, was commemorated in a peculiar *exemplary* and orderly manner. But one individual was found to be disorderly during the day, and he was promptly *put under arrest,* in pursuance of a previous arrangement among them.

FIFTH OF JULY.

As this was the day when, by acts of the Legislature, all slaves within the State were to become free, the Blacks of this village and its neighborhood resolved to celebrate it in an appropriate and orderly manner. Accordingly the note of preparation was heard for some time previous. Subscription papers were circulated, gun powder was procured, and all necessary arrangements made under the direction of an efficient committee. The day, so long and so anx-

A fragment from the Wednesday, July 11, 1827 *Ithaca Chronicle* reporting on the celebrations of the Fourth and the Fifth of July.

at nine in the morning, when "groups of Africans, with happy, glistening faces," gathered for the long-awaited event. Ladies were tastefully dressed and "elegantly decorated." Men wore "plain materials" embellished with a "smart sash, a waving plume, or perchance a regimental coat." At eleven in the morning, the men gathered to form a procession, and there was music as they marched forward to join the women. There were speeches, a sermon by "a Rev. coloured gentleman from Caroline" and then there was a banquet at the Jackson Hotel, where the celebrants dined under the nation's flag. They stayed at the table until late, the younger folks finally going off for ice cream and lemonade. At the end of the evening, like Cinderella, "the tired Africans, highly gratified with the amusements of the day, sought their beds, from which they were soon to be aroused to their customary occupations."

The religious center for Ithaca's African Americans was the home, at Green and Geneva streets, of Reverend Henry Johnson, who had come to Ithaca as an agent of New York City's newly formed African Methodist Episcopal Zion Church. In Ithaca, as early as 1827, Johnson led discussions about creating a church of their own, rather than remaining with the Aurora Street Methodists. It is probable that from these meetings came the idea of political action. In 1828, there was a single notice in a local newspaper that Ithaca's blacks had created an Ebony Party to support the presidential candidacy of John Quincy Adams. There was never another mention of this early political effort. The number of black voters that year would have been fewer than a dozen: to be eligible to vote, one had to be male and possess property worth more than $250. In 1833, members of the "African" class who met at Reverend Johnson's house on Green Street withdrew from the Methodist Church and organized as an African Methodist Episcopal Zion congregation, usually called the "African Church." They erected a building of their own and opened the doors to their Wheat Street church in 1839. In 1857, they fostered a "Methodist chapel," sometimes called the Wesleyan Chapel, or the "colored church," on North Albany Street.

UPHEAVALS

Along with religious revivalism, there was political unrest created by intense anti-Masonic sentiment, a movement that began with a distrust of secret societies and, in particular, hostility to what was perceived as Masonic elitism. This antagonism was fanned by the 1826 publication in Batavia of William Morgan's book *Illustrations of Masonry*, which revealed Masonic secrets, and then by Morgan's subsequent disappearance, blamed on the Masons. By 1827, anti-Masonic feeling was intense. Local ministers charged Masonry with being a "false religion" and antidemocratic. In 1828, religious anti-Masons supported Solomon Southwick as their gubernatorial candidate: Southwick passed through Ithaca in 1834 and a year later wrote an essay extolling it as a place "destined not only to become one of the most favorite resorts of fashion, taste, and genius; but one of the most wealthy and flourishing of inland cities." Truth be told, Ithaca was not yet a city, and Southwick lost his bid for Albany, but anti-Masonic feeling was so strong that members of Trumansburg's Masonic Lodge met for a decade in secret.

In the state, Thurlow Weed and others transformed anti-Masonry from a religious

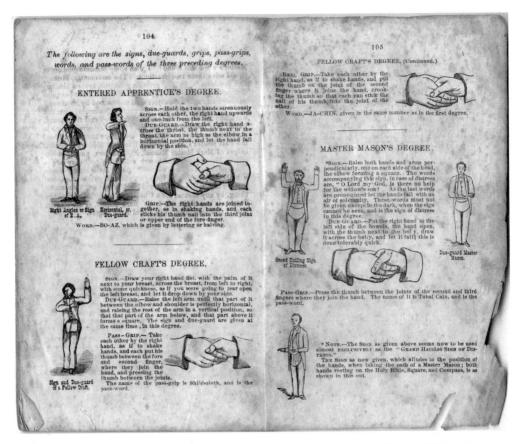

An illustration of Masonic secret signals from *Illustrations of Masonry Revealed* by Captain William Morgan (1870s reprint of 1826 pamphlet). *Collection of the author.*

concern into a political movement, and by 1832 anti-Masonic supporters had created a national political party. Still, the excitement caused by anti-Masonry died down quickly, and local anti-Masons became part of the emerging Whig Party. Together, politics and messianic religious messages pulled people from established organizations to which some returned after their initial enthusiasm waned, but many did not and were, thereafter, people seeking something to believe in and new organizational homes for their political and religious energy.

Getting In and Out

The Reverend F.N. Zabriskie wrote that "it is slow, up hill work to get out of Ithaca in almost any direction," and it was also slow work getting into the village. Nonetheless, people managed to come and go. By 1830, Ithaca was linked to the east and west by the Catskill Turnpike (now Route 79), to the north by steamship and the new overland route to Geneva (now Route 96 north) and to the south by the Ithaca–Owego Turnpike,

RAIL ROAD.

NEW ARRANGEMENT WHILE FINISHING THE ROAD.

TRANSPORTATION TRAIN.

The train of Transportation Cars will leave Ithaca every afternoon (Sundays excepted) at 4, and arrive at Gridley's at 8 o'clock, P. M., will leave Gridley's at 4, and arrive at Ithaca at 8 o'clock, A. M., stopping, both in going and returning, at Howe's Turnout, Whitcomb's and Wilsey's Mills, to take in and discharge loading, and receive Cars that may be in readiness to join the train.

The train of Transportation Cars on the Owego end of the Road, will leave Owego every afternoon (Sundays excepted) at 5, and arrive at Gridley's at 8 o'clock, P. M., will leave Gridley's at 4 and arrive in Owego at 7 o'clock, A. M., stopping both going and returning at 'ones' Cross Roads, Sacket's and Chidsey's Mills, at Candor Corners, and at Booth's Cross Roads to take in and discharge loading, and to receive such cars as may be in readiness to join the train.

No burden Cars are permitted to run upon the Road except such as are registered in the Secretary's Office in Ithaca, and have a Certificate of Fitness from the Engineer, and a way-bill of loading must accompany each car not belonging to the Company's Train, and toll paid at the Gates, at the rate of 3 cents per tun per mile.

DANIEL L. BISHOP, *Secretary.*

ITHACA, July 20, 1838.

Mack, Andrus & Woodruff, Printers.

An 1838 advertisement for the Ithaca and Owego Rail Road. *Collection of the Tompkins County Historian, 31.9.*

a toll road (now Route 96 south). Although Ezra Cornell walked from Homer to Ithaca in 1828, others came by easier means of conveyance. Visiting Ithaca, James Stuart commented that it

> *is a very flourishing village, the centre of several great roads, with a population of between 3000 and 4000 and buildings in rapid progress. It is surrounded on all sides, but that towards the lake, by hills 300 and 400 feet high.*

Ithaca's landscape was lauded and its peculiar position noted.

In 1827, the state rejected a scheme proposed by local businessmen for a canal to connect Ithaca with the Susquehanna River, in favor of a route from Seneca Lake along the Chemung River (which is the western branch of the Susquehanna). In response, local entrepreneurs incorporated the Ithaca & Owego Rail Road Company, the second railroad within New York State. The tracks ran between Ithaca and Owego, using two inclined planes to negotiate South Hill. Built in the form of a semicircle, the upper plane passed just south of the crest of the hill, rising 510 feet within a mile. Horses pulled the railcars along the tracks. When meeting trains coming from the opposite direction, freight trains took precedence and able-bodied passengers lifted cars from the track. The trip between Ithaca and Owego took three and a half hours.

These early routes were also available for those departing. During this decade, some people, especially from the countryside and those who had not been able to establish themselves, began to leave for opportunities—land or employment—elsewhere. More came to than left Ithaca, however, and the village continued to increase in population.

To accommodate transport within the village, trustees built new roads on West Hill. They ordered flagstone sidewalks for Owego Street (now the Commons), between Cayuga and Aurora streets, to answer pedestrians' complaints about the mud. At the same time, the village president appointed Ithaca's first street committee, its members drawn from the existing board of trustees.

Newspapers of the day were aligned to political parties, and political news dominated—and was vehemently partisan. Local political power seesawed back and forth between Jacksonian Democrats and Whigs. According to Thomas Burns, author of *Initial Ithacans*, Ithaca's political parties exchanged control of the village with such regularity, rather like a pendulum, that it was said, "As Tompkins County goes, so goes the State." The ability to serve as political barometer long ago ceased to be true, but this highly charged political situation resulted in Ithaca having two newspapers: the *Ithaca Journal and Advocate*, which identified with the Democrats, and the *Ithaca Chronicle*, which favored the Whig Party. There were often other newspapers that represented splinter positions, although later in the century the papers clearly favored the Democratic or Republican points of view. One of the disadvantages of Ithaca's current government is its lack of political competition because common council today is elected overwhelmingly from one party. This was not true in Ithaca's early years.

Interesting things began to happen in Ithaca. There were expanded educational opportunities, a Bank of Ithaca was incorporated and David H. Burr's beautifully colored *Atlas of New York* was printed in Ithaca—something that certainly came about because

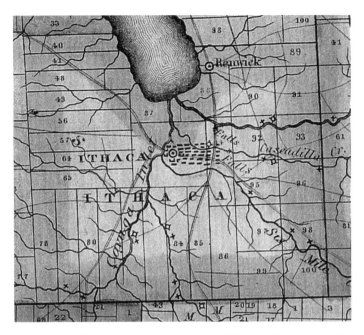

A fragment of Tompkins County from the 1829 David H. Burr *Atlas of New York State. Copy in the collection of the author.*

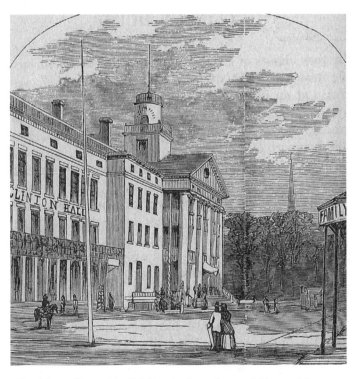

"The Clinton House," by J.C. Burritt, from *Scenery of Ithaca and the Headwaters of the Cayuga Lake* (Ithaca, 1866).

Burr was a former student of Simeon DeWitt and it was DeWitt who commissioned the elegantly engraved book of county maps, contracting the work to Ithaca printers.

The Clinton House enhanced Ithaca's reputation. Built by local entrepreneurs and named for DeWitt Clinton, the hotel cost $22,000 and was considered the grandest hostelry west of the Hudson. It featured spacious public rooms, cleanliness and a fine kitchen, amenities that travelers were not likely to encounter everywhere. The hotel was praised, for the "finish throughout is of the best workmanship, and in the most modern style," and the "furnishing and keeping is in accordance with its splendor and convenience." It was also lauded for its location, "just where good taste would select," in the center of the village near the park on an "avenue which runs from the hill side" down to the lake.

To accommodate the business of life, the trustees opened new streets and added some board sidewalks, but the streets in Ithaca, until rather late in the century, were unpaved. Ithaca's streets also suffered from annual inundation by floodwaters, a consequence of Ithaca's particular and beautiful geography. During heavy rains, the picturesque gorges funneled water onto the flatland. Water then flowed through very uncertain channels that were often blocked by debris, their banks degraded by cattle drinking from them and even by local congregations using them for baptism. Some owners of land along the creeks erected barricades or private dams to siphon water for their own uses, causing disputes between neighbors, but also an uncertain flow of water. Flood and backed-up water frequently breached the sides of the creeks, spilling over the streets and into privies and wells. The village board declared two dams and a "tail race" on Six Mile Creek, along with the box factory dam on Cascadilla Creek, to be public nuisances and ordered them removed. Before they were, however, the owners took the case to court, delaying action from season to season. Water rights and the damage caused by flooding were persistent items on the village agenda, as they would be for another hundred years.

In 1830, Ithaca's population grew past the five thousand mark, and it soon increased as immigrants from Ireland began to appear, diversifying the local population. In Ithaca, however, the Irish encountered a predominantly Protestant community and faced discrimination in the form of fervent "anti-Catholicism," expressed most frequently in the *Jeffersonian & Times*, a Democratic newspaper published in the village. Its editorial writer cautioned Ithacans that "near one hundred thousand Catholics will emigrate to this country in two years. Thus the Catholics have an army here at once, all disciplined." The writer claimed that the Irish were eager to move into positions of responsibility, displacing Protestants. Local office holders were warned to be wary, even by Reverend Wisner, who preached an uncomplimentary sermon about "papal troops" in the United States.

A priest from Owego or Auburn came to Ithaca several times a year, and the congregation built St. Luke's Church. In 1861, they moved that first building to West Green Street, where it is used today as a private residence, and erected Immaculate Conception Church at the corner of Seneca and Geneva streets.

The decade of the 1830s was a time of optimism. In 1836, one newspaper wrote that it was high time "this beautiful village, blest of heaven, and beloved by man, which has hitherto been neglected by capitalists, begins to attract attention." Another scheme,

An example of flooding in Ithaca. *Digital scan provided by Bill Hecht, 229-22999.*

The first Roman Catholic church, St. Luke's, 1851, from the *Ithaca Journal Centennial Number, 1915.*

created by local businessmen, involved creating a link between Ithaca and Lake Ontario by means of a canal to Sodus Bay. This project also presented possibilities for international trade from Ithaca, the intersection with the Erie Canal providing a route to New York City. To complete the circuit, there would also be a new rail line connecting Ithaca with the Susquehanna River in Owego, opening the Philadelphia and Baltimore markets to Ithacans. All this was very exciting and boosted enterprise and expectations. New factories opened, people invested in local real estate and property increased threefold in value. A farm on the village boundary that had sold for $50 an acre was worth $500 an acre ten months later. Water rights, too, sold for large amounts of money. Workers' wages rose to $0.87 a day, and specialized laborers organized a Mechanics Society to accumulate a fund for the benefit of members in times of sickness or death and to protest for better working conditions, such as limiting the workday to ten hours. Boom times seemed to be at hand. Private citizens erected streetlamps, nine fueled by oil and seventy-seven that used gas. The board of trustees agreed to maintain them.

SADLY, NOT SO ISOLATED

The great transportation scheme of 1836 was a means of combating Ithaca's physical and economic isolation. In the 1950s, Frances Perkins, secretary of labor in President Franklin D. Roosevelt's cabinet, spent several years living here, connected to Cornell. She found Ithaca's location awkward and called it the "most isolated place on the Eastern Seaboard." While Ithaca had many advantages, it was not well connected in the 1950s and was even less well connected to routes of trade in the 1830s. The Sodus Canal would have countered Ithaca's awkward distance from markets. Before action could be taken making the 1836 scheme a reality, however, events elsewhere reverberated in Ithaca and brought down these grandiose schemes, proving that Ithaca was not immune from national economic trauma and not as unconnected as Perkins's affectionate jab suggested.

In Washington, President Andrew Jackson struggled with the nation's banking interests, leading to a financial panic. The Depression of 1837 was slow to show its effects in some upstate communities, but in Ithaca it quickly and significantly depressed land prices. Plans for Ithaca's future were shattered. Business came to a standstill, and workers' wages fell to fifty cents a day. One writer observed that in 1836 and 1837, "Ithaca suffered severely from financial panic which did much to terminate dreams of commercial and industrial greatness." Closing the door on prosperity, "the fates seemed to frown upon the efforts of its big men to create a transportation center."

Alarmed at the state of affairs, and angry with the village's Democratic leadership, members of the local Whig Party created a "vigilance committee." In the fall election, this Whig group surprised the Democrats at the polls, taking every seat but one—the only candidate who failed to win was Ezra Cornell, running for trustee. Despite this political sweep, the Whigs were powerless to relieve the economic conditions depressing the village because the problem was national. Locally, the plans for canal, shipyard and rail line were abandoned, and a number of people who had been attracted to Ithaca

because of the boom times left. The courts dealt with the others—"men and women of bad character and disorderly conduct." Village hopes and its economy were dashed.

Despite this setback, some things were accomplished. The village implemented the plan first devised by Simeon DeWitt to extend streets the length and width of the flatland, setting in place the pattern on which we live today. Perkins would have appreciated a major railroad line connecting Ithaca to elsewhere, but when Ithacans attempted to counter their location in 1836 with just that, their rail and water transport scheme failed. Despite the local gloom, articles appeared in distant newspapers extolling Ithaca's beauty, calling Ithaca an "important place," situated in a lovely valley and connected with railroad lines and lake steamers. Small promotional acts were not enough, however, to alter the reality, and there was quiet in the village as the air of hope seeped from the balloon of prosperity.

Over the next decade, the once buoyant population sobered, and anticipated fortunes vanished. Local promoters, hoping to turn around the village's fortunes, sent Ezra Cornell to the east to entice a manufacturing company to relocate in Ithaca, but he failed to find any willing to take a chance. The village made some attempts to spruce up its image, replacing the wooden sidewalk planking with stone on Owego Street and placing restrictions on the erection of wooden buildings in an effort to prevent fires. But local commentators wondered when the citizens of Ithaca would awaken from their lethargy, "which has for so long time rested upon them, and emulate the enterprise of the inhabitants of the cities and villages about them?" And even more harshly, the *Ithaca Journal* wondered what chance Ithaca had "to retain the trade of her own county? She lost that of every other except perhaps Tioga by the Chemung and Chenango canals years ago."

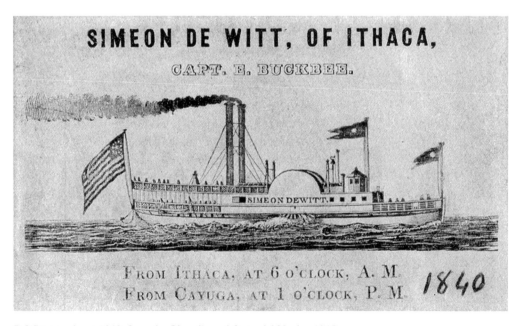

DeWitt steamboat, 1840, from the *Ithaca Journal Centennial Number, 1915.*

FIRE AND FLOOD

Fire was easily the greatest danger to any community, especially where houses were set close together and built of wood. It took the night watch, the fire companies and volunteers to deal with the threat of fire. In one year, there was a fire in Mrs. Bishop's barn, the Merchants' and Farmers' Bank burned, Finch's storehouse went up in flames, Apgar's carpenter shops burned down, as did Burritt's barn, and the Woolen Factory succumbed to arsonists' flames. Some fires were caused by arsonists, some occurred by chance and there might have been "insurance fires," intentionally set so that small-factory owners could collect enough cash to modernize.

On May 28, 1840, fire broke out on Owego Street in a building being refitted as a theatre. Fourteen buildings on Owego and Aurora streets were consumed or partially damaged. They housed several jewelry shops; a confectionary; a druggist; two hat, cap and fur stores; law offices; a tin, stove and hardware manufactory; and several dry goods shops. One private home was lost. The total damage was estimated at $65,000, with only half the businesses insured. Collecting on policies depended upon estimates of the insurance companies and their solvency. Nineteenth-century fires were frequent; every village suffered from them, and any cluster of buildings was vulnerable because most structures were constructed of wood. The age of brick arrived later, usually after there had been what Nathanial Hawthorne called "purification by fire."

Ithaca's 1840 fire occurred while Henry Walton was living in Ithaca. He had completed three views of the village, one from each of the hills. In 1840, he captured the fire scene

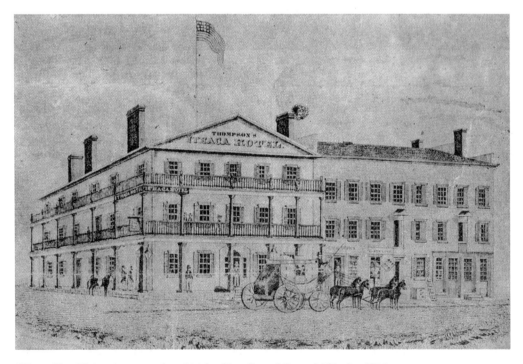

"Ithaca Hotel," drawing, reproduced in the *Ithaca Journal Centennial Number, 1915.*

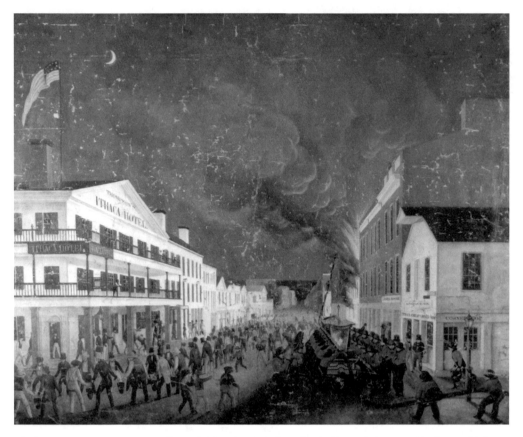

The Ithaca Fire Banner, painted by Henry Walton in 1840. *Reproduced with permission granted by Raymond Wheaton of the Ithaca Veteran Volunteer Firefighters Association. Digital scan courtesy of the History Center in Tompkins County.*

in a large painting that shows a water pumper manned by a uniformed fire company and a bucket brigade stretched along the street in front of the Ithaca Hotel. The *Ithaca Chronicle* commented that while its building had been spared, and while the paper appreciated all those who worked to save the remainder of the town, "too many looked on the scene of destruction with careless indifference, and could not be urged to lend assistance when so much needed." Notice the people in Walton's painting standing on the balcony watching the efforts made to stem the fire. Recovery from the damages of the fire took time.

In addition to fire, there were threats to public health. Trustees passed sanitary rules and appointed a health officer, but there was always a question about the quality of Ithaca's water supply, which came from wells. Wells on the flats were often dug in unstable land subject to flooding, and they were often located near privies. Many people carried water home from a common source. In 1853, trustees granted permission to a private group to "dig a ditch to lay pipe to bring a pure supply of water to the village." This led to the incorporation of the Ithaca Water Works in 1853. At the same time, the Ithaca Gas Works sought incorporation. These two important utilities were both conducted by private companies.

The trustees assessed property owners along Lake Avenue for money to build a plank sidewalk to Steamboat Landing, banned "fast driving" on village streets, expanded the street system and built bridges needed to facilitate movement from one part of the village to another. The costs of these improvements were high, and the village resorted to offering notes to its creditors.

In 1857, rain highlighted the problems created by Ithaca's particular landscape. Rain pelted the area, swelling the creeks and causing major flooding that sent water of "unprecedented proportions" through Ithaca, destroying property and causing the deaths of several people. For some weeks, the lowest-lying parts of Ithaca remained underwater. The trustees responded by establishing a standard of seventy feet for the bed of Six Mile Creek and thirty feet for Cascadilla Creek. It sent a team into the marsh at the end of the lake to determine if impediments to water flow could be identified. The village president appointed new health commissioners, and in response to the great need of flood victims, trustees formed a committee to solicit provisions for the suffering poor. This is the first time we hear of any governmental relief outside the activities of the poor master or of the county poorhouse, home to those judged incapable of caring for themselves.

The trustees also acted to secure public spaces. The city fenced Washington Park, filled it in and finally landscaped it in 1908. The city agreed in 1856 to maintain DeWitt Park, recognizing its significance to Ithaca's civic life, while the Presbyterian Church retained title to the land. The agreement between village and church states that the park is to be "a public walk and promenade, and that no houses or other buildings, except ornamental improvements, be erected or made thereon, and that no dead bodies be interred therein," ensuring that the park could not be turned into a cemetery.

Home of the first Ithaca Post Office, located on the Commons, from the *Ithaca Journal Centennial Number, 1915*. Note the basement level.

Trustees built a new jail to replace the one erected in 1817. Yet, in 1857, Ithacans were astonished by the escape by Edward Rulloff, who took with him the jailer's son. Rulloff had spent years in Auburn Prison and was in Ithaca for his second trial in an attempt to determine the cause of the disappearance and probable poisoning of his wife and child. When he left Ithaca, Rulloff embarked on a curious career of crime, ending with the murder of a sales clerk in a Binghamton store. In 1872, Rulloff was hanged while urging the hangman to hurry that he might be in Hell in time for lunch. That year, the first account of his life appeared in print. Samuel D. Halliday, a prominent Ithaca lawyer, wrote another account in 1906, and in 2007, Stephen D. Butz published *Shall the Murderer go Unpunished: The Life of Edward H. Rulloff, New York's Criminal Genius.* Also in 1857, trustees directed "gentlemen boarding with Jailor Jarvis," as "they have leisure," to clean the gutters throughout the village. They passed an ordinance against driving horses along the Cascadilla streambed, as hooves degraded the sides, and responded to the damage done by fires by posting a reward for reporting "fire bugs."

The village had always functioned in a somewhat haphazard fashion. In 1859, when Thomas St. John, a banker, became president, he reacted to the lack of procedures. The growing complexity of government, as it assumed more duties and spent more money, St. John pointed out, required greater accountability. He insisted on keeping a record of work orders, a systematic method of bookkeeping, and he opened board sessions to the public. He viewed the mounting village debt with alarm: it was $10,546 in 1859. Despite health laws, farm animals still roamed the streets. St. John ordered that domestic

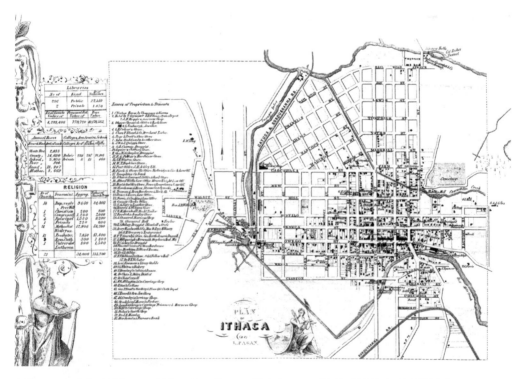

A fragment of the 1853 map of Tompkins County. *Digital scan provided by Bill Hecht, 230/23012.*

geese be kept from the streets and imposed a ten-cent fine for redeeming each bird from the pound. The trustees also passed regulations that landowners clean village streets every Saturday; obviously, using the prisoners had not worked out. The village added pavement to State Street from Geneva to Fulton, increased the size of the cemetery and appointed a board of fire engineers to create a code to promote fire prevention. In recognition of the importance of firefighters to the health and safety of residents, the village placed a monument in the city cemetery in 1861. The debt declined slightly, but there was no reserve.

By mid-century, Ithaca had sixty-eight streets. There was a range of employment, and unskilled laborers could hope to find work among the village's 163 commercial enterprises. The school system expanded, although there were 58 illiterate individuals in the village. Ithaca's white population in 1850 was 6,911, and many owned their own homes and land. The black population rose to 169, showing a small increase; many were individuals who had been born south of the Mason-Dixon line and likely liberated themselves from bondage. Ithaca's ethnic mixture included Canadians, English, Scots, Irish and Germans.

THE POLITICAL MIX

Of all that happened in Ithaca between 1830 and 1860, the most compelling thread to follow is the political debate caused by the existence of slavery, actively discussed in the local press and most likely on the streets. Those opposed to slavery focused on how slavery might be ended and the admission of new states, either as slave or free, into the Union.

A segment of the population preferred the idea of colonization, thinking that the best solution to enslavement was to return African Americans to Africa, thereby removing an unwanted minority from the land and also sending people to what was considered the "dark continent," where they could bring education and Christianity.

There were those who thought that any colonization plan was a half measure, and many activists joined antislavery societies; three in the county were founded by Dr. Dyer Foote of Lansing. Antislavery advocates thought colonization was morally wrong because all slaves could not be freed at once, and owners would be compensated for their loss of "property"—both of these were indefensible positions to abolitionists. In addition, abolitionists thought that transportation of all African Americans was impossible. Antislavery proponents also feared that if slavery spread into the territories, it would knock askew the delicate national balance between slave and free states. Local abolitionists sent petitions to Congress to end slavery in Washington, D.C., to prevent the spread of slavery in Texas and to prohibit slavery in the territories. These petitions were addressed to former president and congressman John Quincy Adams and are preserved in the National Archives in Washington.

Reverend Wisner, on the other hand, refused to allow discussion of slavery on Sunday—or on God's time—and so angered a group of his parishioners that they left his church to found a Congregational Church that has also been called "the Abolition

Church," at Hayt's Corners on the road to Trumansburg. Among those who abandoned the downtown church were Benjamin Taber, a boat builder; Salmon Higgins and his family; and Benjamin Halsey, a druggist—all staunch abolitionists. At a Presbyterian General Assembly meeting called in Detroit to deal with the question of slavery, Wisner presented a minority report deploring slavery "unless the civil law and other circumstances over which the individual has no control, require" it. His position was that there were two realms, one of God and the other of Caesar, and that neither should question the authority, nor encroach upon the rights of, the other.

In 1846, when voters across the state were asked their opinions about granting suffrage to Negros, only 26.2 percent of male voters in the county approved. Phyllis Field shows, in her book *The Politics of Race in New York: The Struggle for Black Suffrage in the Civil War Era* (1982), that in 1860 the percentage of approval of suffrage within the county had risen to 48.7, a leap of 22.5 percent. By 1869, approval for the measure came from 60 percent of county voters. There was no local discussion of suffrage, none recorded by Ithaca's 325 blacks and nothing at all in the local press about granting suffrage to women, black or white. There was also no mention in the local press of the 1848 Woman's Rights Convention held in Seneca Falls, and only mocking references were made to women's rights over the next few years.

There were some fugitives from slavery who fled through Ithaca, but the number is not high, and Ithaca was not a comfortable place because of the presence of so many Copperheads, or Northern Peace Democrats. Thomas Burns wrote that when George A. Johnson was a boy, he helped secure passage on steamboats by applying to Ithaca's prominent white lawyer Ben Johnson for funds. Some households have stories of hiding places for those fleeing through Ithaca, and that might have happened. The truth is that there were better, safer routes. Harriet Tubman did travel though and left several escapees from the South with family and friends in Ithaca. Jasper Woodson was one former slave who lived out the rest of his life here.

In response to the Fugitive Slave Act, signed into law by President Millard Fillmore in October 1850, Ithaca's black population organized the Ithaca Colored Citizens Society. They met at the home of Titus Brum, an elder of the community, on South Cayuga Street (where there is a car dealership today). They issued a set of resolutions, quoting from the Declaration of Independence, as had the women at Seneca Falls in 1848. The Colored Citizens Society insisted on the right of "every bondsman to seek freedom." It resolved that, despite the provisions of the Fugitive Slave Act, it was the duty of every person to aid fugitives, and it expected that all doors should be open to those fleeing bondage. The resolves stated that the "colored citizens of Ithaca," governed by the laws of the state, "do not consider the Fugitive Slave Act to be constitutional," calling it a "disgrace to all who profess liberty." These local black men wrote that they believed "the moral and political sentiment of our town is in our favor." Here, of course, they were speaking for themselves, for while there were some in Ithaca willing to aid fugitives, there were others who did not dare to break the law or, for their own reasons, were opposed to giving aid to fleeing slaves. The Ithaca Colored Citizens Society ended its resolution with the declaration, "Give me Liberty or Give me Death."

The Greening of Ithaca

The debate about slavery took place within a diverse population, both ethnically and economically. Even if fabulous wealth had not been the result of the failed transportation schemes of the 1830s, there were people in Ithaca with means who lived amid a growing population of laborers competing for work. The 1855 state census listed over 1,400 people who had been born outside the United States; the number from Ireland reached 1,177. In this difficult economic situation, there was rivalry between Irish immigrants and blacks, the Irish resisting any effort that would increase competition in the job market. Tension between the Irish and blacks escalated, even while they lived close to one another—Irish at the west end of Wheat Street and blacks clustered on the block near the AME Zion Church.

As these Irish newcomers became citizens—those who were male, over the age of twenty-one and had resided in the country a sufficient number of years—their choice of political party was limited. Whigs harbored nativist, anti-foreign ideas so most local Irish voters joined the Democratic Party. Their presence, however, must have challenged the local leadership, who saw their political base changing. The major parties, the Whigs and the Democrats, splintered into diverse points of view, and members of the old Democratic leadership, in particular John Selkreg, editor and publisher of the *Ithaca Journal*, found themselves in a political quandary.

The emergence in 1856 of the new Republican Party, a coalition of a combination of Whigs, Free-Soilers and antislavery Democrats, made it possible for an interesting local political decision to occur. In response to the nomination of the first Republican presidential candidate, the *Ithaca Journal* announced in an editorial that, although the paper had long been the "unwavering organ" of the Democratic Party—and its editor Selkreg among the most important Democratic Party leaders—it now believed that slavery was "the great question which over-rides all others." The newspaper announced that to be true to its "democratic" principles, it was "compelled" now "to sustain the principles and men of the Republican Party." This was a dramatic shift of allegiance and, with it, a number of local Democrats moved into the Republican Party in 1856. After the war, only a handful returned to the Democratic fold.

War and Consequences

The election of 1860 revealed the political differences that had been growing between voters in Ithaca and between opinion in Ithaca that differed with the rest of Tompkins County. Republicans supported the nomination of Abraham Lincoln as its presidential candidate, even as it came as a surprise that the state's most prominent Republican, William Henry Seward of Auburn, was not the party's candidate. Their choice was clear.

For their part, the Democrats, already a divided party, splintered apart. Most New York Democrats overwhelmingly supported Stephen A. Douglas, but Southerners in the party nominated John C. Breckinridge, who had some New York backing, though little hope of winning the state. In addition, John Bell became the candidate of the

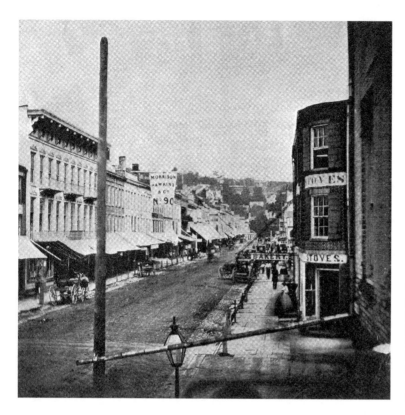

This photo, taken around 1860, is from the *Ithaca Journal Centennial Number, 1915.* The rod projecting into the picture is a drain spout that dumped rainwater onto the street.

Constitutional Union Party. In an effort to wrest the state from Lincoln, leaders of New York's Democratic Party achieved unity of the party's factions in an interesting maneuver called the "Syracuse juggle." On the ballot, there were electors for Lincoln and electors for a Fusion ticket, representing the Democrats, all having agreed to apportion votes to the candidate most likely to win. Lincoln captured the state by a vote of 362,646 to 312,510, a 50,000 vote difference in favor of the Republicans. In Tompkins County, following the state's example, Lincoln received 4,348 votes, the Fusion ticket 1,300 fewer. The outcome in Ithaca, however, as in New York City, was a vote for Fusion. In Ithaca, Abraham Lincoln received 676 votes, while 860 voted for the Fusion ticket, a difference of 116 votes.

Confirming this preference for the Democratic Party, throughout the decade of the 1860s Democrats held the office of village president for all but one year. As in many instances, Ithaca's diverse population, with its laboring class, went its own way, reflecting the same concerns of New York's larger urban centers rather than its nearer rural neighbors. In the state in 1863, Democrats ousted the Republicans and installed Democrat Horatio Seymour as governor.

In 1861, the national trauma began. When news of the attack on Fort Sumter reached Ithaca, residents prepared for war, and by April 24, there were forty-eight volunteers ready to fight. Citizens created a fund to aid the families of those who enlisted, and businessmen displayed American flags. The DeWitt Guard, the local militia established in 1851, announced itself ready to fight, and black male residents of the village met and

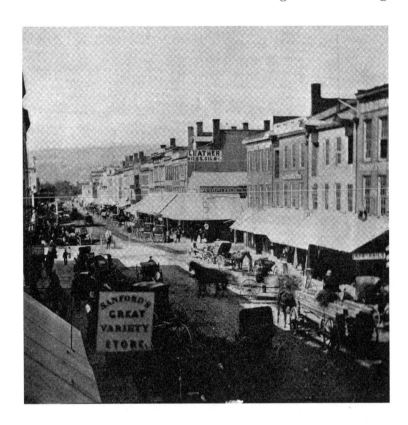

State Street, around 1860, from the *Ithaca Journal Centennial Number, 1915.* Note the wooden awnings and the numerous farmers' wagons.

passed a resolution announcing their willingness to volunteer to defend the Union. New York designated Ithaca a training and embarkation point, and the Tompkins County Bank loaned New York State $25,000 to meet the crisis.

Men rode trains off to battle, and more than 500 from Ithaca enlisted. Some did so willingly, thinking the war would be quick and that they would return as heroes. Others needed encouragement to join. To meet its quota, the county offered a bonus upon signing. The state paid $50 and the Federal government $102, besides regular pay, board and clothing. Would Ithaca have to ante up money to find enough men to meet its required 212 recruits? Would a draft be necessary? Men went off to the 21st New York Cavalry, the 10th, 32nd or 137th New York and other New York regiments. At home, Ithacans read the newspapers about the course of the war, and they poured over letters sent home, in which soldiers wrote of hours spent waiting, marching with heavy packs, bad food, boredom, aching backs, sleeping on the ground and rain in torrents. War meant being homesick and frightened.

The war came home to Ithaca in 1862, when the newspaper announced the first three local deaths: one from wounds received in battle and two from sickness. Some soldiers returned to Ithaca in 1863, their way paid so that they would be home for the election. They were celebrated at a grand reception, but they also congregated in the streets, and when the soldiers refused to disperse, firemen threatened them with hoses ready to "wash out" the men and also residents of "several notorious brothels." That year, the village election turned out the Democrats.

A few of Ithaca's black males left the county to enlist with troops in states that would accept African Americans. Some went to Massachusetts to join its black regiments, the 54th and 55th. Others went south to Pennsylvania. Ira Brum, who had grown up in Ithaca, joined the 185th New York Volunteers, the only "colored man in his company." Even while African American men were eager to fight, New York and its Democratic governor were reluctant to enroll them, believing their presence would enrage the South and prolong the war. Facing a quota from the Federal government that it could not meet, however, New York finally accepted a compromise, agreeing in 1863 to allow its black citizens to enroll in Federal units but credited to the state's quota. In December, a recruiting officer arrived in Ithaca seeking men for the 26th United States Colored Infantry. He held a series of meetings, beginning December 23, in the African Church on Wheat Street and asked able men to step forward to enlist. At least thirty-six black men from the county marched off to war.

WHAT EZRA CORNELL SET OUT TO DO

While the Civil War raged, circumstances in Ithaca altered its future. History is often portrayed as trends, or forces, or even as events that were in some way inevitable, but the importance of individual vision and will cannot be overstated. There have been people whose acts and ideas shaped our past. Simeon DeWitt saw the possibilities of a piece of land nestled at the foot of our local hills, and we live with the consequences of DeWitt's vision and his specific design. Ezra Cornell also brought about dramatic change in Ithaca, creating a future for the village unimaginable at the time. Residents were in awe: Cornell had come to Ithaca in 1828, a gangly youth who worked at various trades. He had taken up an interest in the telegraph industry and, after years of struggle, had made a fortune. Settled back in Ithaca and wealthy at the age of fifty-four, in 1861 Cornell won a seat in the state legislature. The next year, he became president of the New York Agricultural Society, a prime instrument of agricultural education and sponsor of the Agricultural College in Ovid, to which Cornell sent one of his sons. In Albany, Cornell encountered opportunity and altered the village's future.

Unlike many other wealthy men of the day who tucked their money away to enrich their heirs, Cornell was interested in using his money during his lifetime "to do the most good." In 1862, he offered to create a free public library for the citizens of Ithaca, first considering a gift of $20,000, but as the idea expanded, he pledged more. In the end, he spent about $100,000 to erect a grand building at the corner of Seneca and Tioga streets. Free public libraries were rare at the time, and earlier book collections in Ithaca had been based in churches, at the academy or had been funded by membership fees, some as high as $10 a year. Cornell believed that the library, "to be successful, must possess the means of self support." He designated two floors of the building to house book collections and patrons, with rents from the post office housed on the first floor and various associations, including a newly established historical society, on the top and in the lowest level. There was a lecture room that seated "comfortably about 800 persons," in contrast to the much smaller space available in the village hall. Cornell donated three

A portrait of Ezra Cornell (1807–1874),
donor of the Cornell Library and
Cornell University, from *History of Tioga,
Chemung, Tompkins, and Schuyler Counties*
(1876).

thousand volumes and pledged one thousand books each year thereafter. He made it the
responsibility of the citizens of the county to donate money for books and staff and to
maintain the library—a pattern followed some years later by Andrew Carnegie. In 1863,
construction of the library began.

New York State incorporated the Cornell Public Library Association on April 4, 1864.
The library opened to the public in December 1866, and at the end of his remarks
on December 10, 1866, published in the *Dedication of the Cornell Library Building*, Ezra
Cornell declared: "Fellow citizens of Ithaca, this property belongs to you." Most citizens
felt overwhelmed at such a gift, and it is a moment of great significance in Ithaca's
history, establishing an important philanthropic tradition. The library was predicated on
community collaboration and opened its doors to everyone. At the inaugural ceremony,
Benjamin Ferris asked in wonder, "How many counties like Tompkins, how many towns
like Ithaca contain the visible evidences of private munificence for public use?" Indeed,
the library was a tremendous gift, all the more so because it was not the product of
a committee or of public yearning, but came from Cornell's belief in the power of
education and self-improvement. Ferris observed that the bibliothèque in Paris had begun
with twenty volumes; the great library at Oxford University with six hundred books.
What Ferris was doing is very interesting and important, for he was comparing Ithaca,
with a population of fewer than eight thousand people, with the world's great cultural
centers: the legendary libraries of Alexandria, Paris, Oxford and Berlin. The analogy
was audacious, but so pleasing to a people hoping to distinguish their village that it might
grow and prosper. The Cornell Library gave Ithaca something to crow about.

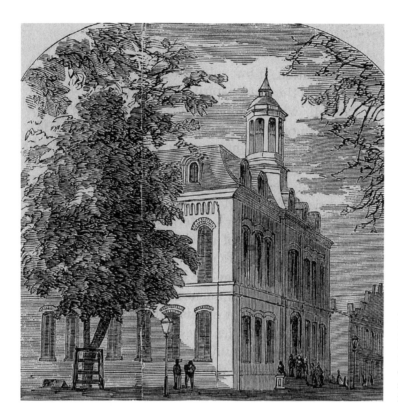

This photo by J.C. Burritt of the Cornell Library, located at the northeast corner of Seneca and Tioga streets, was reproduced in *Scenery of Ithaca* (1866).

Seeing an opportunity to advance her own cause, Samantha Nivison approached Ezra Cornell about a project she believed would also bring fame to Ithaca. Nivison had apprenticed with her uncle, a doctor, and had spent time at a water cure. She believed that nursing at such a facility was within the scope of what women might do. She proposed that Cornell and his wealthy friends build a water cure hospital in Ithaca that would draw visitors to the community, while also providing professional training for women. Cornell and some other local investors found the idea of interest, although they mistrusted Nivison's ability to manage the finances of such an institution. They agreed to build a hospital but kept the deed and financial control in their own hands. They created a large stone building on the edge of Cascadilla Gorge, and Nivison began to plan her institution.

There was, however, an unexpected consequence to the application made for the library charter. That document went from Ithaca to Albany for approval. The clerk directed it to the chairman of the State Senate Committee on Literature (meaning education). That senator was Andrew Dickson White of Syracuse, one of the best-educated men in the United States. He had attended William Smith College in Geneva, Yale University and had pursued advanced studies in Europe. When White returned to the United States, he turned down an offer to teach at Yale, believing that college too rigid to tolerate his new ideas about the teaching of history. He went, instead, to the University of Michigan. When his father died, White returned to Syracuse to care for his father's business interests and to look after his mother. Shortly after, he was elected to the New York State Senate,

From an 1882 bird's-eye view of Ithaca, showing Cascadilla Hall, Cascadilla Gorge and the road to Sage College for Women (1875) at Cornell University. *Courtesy of the Map and Geospatial Information Collection, Cornell University Library.*

to which Ezra Cornell was elected in 1864. Cornell, chair of the committee dealing with agriculture, was the oldest member of the senate; White, chair of the committee that dealt with education, was the youngest.

THE UNIVERSITY

White was struck by the generosity and wisdom shown by Mr. Cornell in donating a library to Ithaca. The two senators did not know each other, but they were brought together by New York's acceptance of the 1862 Morrill Land Grant Act. That bill, passed by Congress in the early years of the Civil War, offered the proceeds of land sales to each of the states to fund a college to teach agriculture, engineering and military science. There was only moderate attention paid to the Morrill Act at the time for there was already a great deal of land for sale, and there were few buyers. In addition, in 1862, many of those who would be scholars were at war.

Under the terms of the Morrill Land Grant Act, New York was to receive the proceeds from the sale of 989,920 acres of land. Because there was no federal land in the state, New York was given the right to sell land located in the Midwest, especially in Wisconsin's vast pine forests where there was little settlement. The older, established colleges in the state—Columbia and Union Colleges—were disinterested in this federal scheme to encourage agriculture and engineering education, which were thought by

traditional colleges to lie outside the academic tradition. There were two contenders, however, for the grant money. One was the Agricultural College in Ovid, which had little hope or desire to engage in the teaching of engineering and had closed for the duration of the war. The other was the People's College founded by Charles Cook, who was also a member of the state senate.

The senate designated Cook's school in Montour Falls, at the time called Havana, as its Morrill Land Grant Act recipient. To receive the grant, the People's College was given three years to acquire a farm, equip engineering laboratories, hire faculty and make improvements. There was a scurry of activity in Havana as Cook attempted to fulfill the requirements. But unexpectedly, Cook fell ill, and no one else had the authority to act. Time passed.

Ezra Cornell worried about the lack of progress in Havana. Cornell suggested to the New York State Agricultural Society that it apply for half the land script and he would donate enough money to make up the difference. He thought the Agricultural College in Ovid could fulfill at least part of the Morrill Land Grant Act. This seemed a reasonable plan, but Cornell had not figured on young Senator White, who simply said "no!" As chair of the Committee on Literature, White had long been interested in creating a "modern" or ideal university, as well as a "great work" for himself. He, too, knew of the situation in Havana.

White cautioned Cornell against splitting the land grant money. Something needed to be created, he insisted to Senator Cornell, that was worthy of the state of New York. His idea was to found a university that would promote scientific learning, foster dynamic teaching, challenge students to think and base education upon a great library and scientific methods. White's ideal university would have fields for agriculture and halls for classical studies; it would educate the children of New York's school system with the intention of sending some of them back to teach in the state's public schools. It would be a university free of religious influence, free of old ideas, free of teaching by rote and free to explore the future. It would be open, said White, to any person. "Person!" What a revolution in a word: "person" meant anyone of any or of no religious affiliation, of either gender and of any race. At the time, it was a radical concept.

Half the money would not do, White insisted. In fact, White had the audacity to suggest that, while he could donate some of his fortune to a new university, he saw the need for all the land grant money plus the money that Cornell had offered the Agricultural College. Together, they would create a university to challenge the stodgy educational curriculum of the past.

Ezra Cornell was a man, observed historian Carl Becker, who "said little, and that little dryly." Cornell was most likely mesmerized by White's eloquence and his grand plan. He agreed to give $500,000 to buy the land script for a new university. The two men would work together to create a modern institution, and among those persons to be educated would be poor boys—much as Ezra Cornell had been as a youth, eager for education but unable to afford it—who had never before been able to dream of a university education. Ezra Cornell offered to donate his farm in Ithaca. This was surely not welcome news to White. He had envisioned his ideal university flowering in Syracuse, a city of some size and culture. When White's wife heard that the university was to be in Ithaca, something of a "one horse town," she refused to move. But Ezra Cornell held firm and declared that he wished to do something for the village where he had lived and his children had

grown to maturity. It would be in Ithaca. And linking past and present, the new university would take shape on Cornell's cow pasture, which had begun as the model farm created by Simeon DeWitt, who, in 1819, had promoted the idea of a college for the children of well-to-do New Yorkers that they might become agriculturists.

As the time ran out on Cook's People's College, the state senate heard White's proposal. There was political deal making, some concerning the passage of crucial railroad legislation that White threatened to hold up, before the senate agreed that New York's Morrill Land Grant College would be sited in Ithaca, a village where most of the streets were still unpaved. To encourage this plan, the village trustees paid train fares for a number of citizens to travel to Albany to lobby members of the senate. When the senate approved the charter, the new university trustees met in Albany and then, later, in Ithaca. They absorbed Cascadilla Hall into the plan for the new university, leaving Ezra Cornell to deal with the perplexed letters of woe sent by Samantha Nivison.

The state gave Cornell and White two years to prepare for the opening of the university. When they needed more time, the senate agreed to a third. White created a plan of operation and went off to Europe to buy books and specimens for the laboratories, works of art and to hire a few faculty members. He shipped boxes back to Ithaca and asked Cornell for more money. Cornell oversaw the construction of the first three buildings, South University (now called Morrill Hall), North University (now White Hall) and

A fragment from the 1873 bird's-eye view of Ithaca from the east, showing the first three buildings at Cornell University, with faculty housing scattered about. *Courtesy of the Map and Geospatial Information Collection, Cornell University Library.*

McGraw Hall. Despite their preparations, both men worried that students might not come. Cornell placed an advertisement about the new university in Horace Greeley's *New-York Tribune.*

On Cornell's inauguration day, October 7, 1868, there were 412 students, examined and ready for class—one of the largest enrollments anywhere in the nation. There was a faculty of twenty-six and one complete building, with two others under construction. The campus, Cornell's pasture, was uneven and still reeked of cow. There was a barn, the university farm, plans for engineering buildings and, wondrously, a library collection exceeding thirty-five thousand books.

Inauguration ceremonies began at the Cornell Library on Seneca Street and then moved up the hill. White explained the revolutionary nature of the university. Cornell spoke about the fact that nothing was complete and that nothing would ever be finished: the nature of this new undertaking was that it would always be expanding the boundaries of the academic world, it would always be in a state of becoming. Ezra Cornell declaimed the motto: "I would found a university where any person can study any subject." Jennie McGraw donated chimes that hung that day in a wooden scaffold and, when rung, could be heard clearly in the village below. Louis Agassiz, the great Swiss scientist from Harvard College, said that the inauguration of Cornell University marked "a new era in the history of education." And so it did. Cornell was an embryonic university in a land of colleges.

The story of the birth and growth of Cornell University has been told by Carl Becker in *Cornell University: Founders and the Founding* (1943), by Morris Bishop in *A History of Cornell* (1965) and in my book *Cornell: Glorious to View* (2003). Important to the history of Ithaca is that local men served as trustees and on the early faculty, and the village changed and benefited from the university's presence. Even though there were moments of economic depression thereafter, the university provided a steadying influence.

A view of East Seneca Street and East Hill taken from the Clinton House, from the *Ithaca Journal Centennial Number, 1915.*

COLLEGE TOWN

The university challenged the village and changed it, expanding the population and bringing economic growth, but also fostering diversity of society, opinions and needs. What emerges during these years leading to the twentieth century is local government attempting to cope with the costs of change and changing itself. Students and faculty compared Ithaca with other college communities, and not always favorably. There is the undocumented story of the professor who came to take a job at Cornell, stepped off the train, looked about and boarded the next train out of town. The collegians' view of Ithaca forced Ithacans to look again at the village, where, admittedly, much needed to be done, especially to ensure public safety.

The village responded by sprucing up, buying new fire equipment, numbering residences and placing legible signs on the streets. The public park was officially named DeWitt Park, and the village created a "three-cornered square" named Thompson Park, although no one today has any idea who Thompson was. Owego Street became State Street, and the road up the hill to Cornell was named University Avenue, though not until after Ezra Cornell built his home on the winding road heading to the top of the hill.

The consequences of growth led trustees to amend the village charter and increase the village debt by $7,500. When it reached $30,000, officials viewed it with alarm. In response, the trustees submitted a proposal for a special tax of $7,000 for each of three years, a sequence of taxes that, surprisingly, voters approved. In 1868, Quarry and Fifth streets were opened, Dryden Road, University Avenue and Hudson Street were widened and gas lamps were installed on the streets. The village spent more than $10,000 on street improvements in 1870, including the first paving of State Street between Aurora and Tioga. The Cayuga Lake Railroad gained a charter for service between Ithaca and Auburn, and a factory opened along Fall Creek for the manufacture of agricultural implements. Cigar workers, laboring in rooms above State Street, went out on strike, and replacements arrived from New York City. There were numerous accounts of baseball games, and a velocipede appeared on village streets. The Ithaca Savings Bank opened in 1868 with 1,171 depositors.

The presence of students in Ithaca has always been regarded as a mixed blessing. In addition to their economic contribution to the community, they rang fire bells as pranks, sang at night in the streets, lifted gates and overturned garbage bins on Halloween and created fraternities in which drinking became a tradition. They rushed along Owego Street in class battles and often times forgot to pay their debts. They fueled the local economy with their needs and enlivened the community with their presence.

In addition, the university was dependent upon the village. Cornell began with no intention of providing housing for students, and not until after World War I were there any dormitories for men. Many Cornellians lived with Ithaca's residents, for those with extra rooms took students in as lodgers. Moreover, students needed coats and pens and paper and books and lamps. Ithaca provided these, too. Laborers found work at the university, as did nurses in the infirmary, clerks in the library and men who tended the grounds and worked on the new buildings. Faculty came to Ithaca needing homes and provisions. The cost of all this was that Ithaca was transformed from a small town, where people were

known to each other or were recognized as belonging, to a village where it became routine to encounter strangers on the street. One man commented that, in the past, there had been no university or streets full of strangers, "as we do [have] now." Ithaca novelist Janet O'Daniel wrote of a man who found that the "town's getting too busy for me...I don't recognize it anymore." In 1870, there were 8,462 people listed in Ithaca's census.

New churches divided theology in more precise sectarian slivers, allowing worshippers to fit service and dogma to their particular liking, and older congregations replaced their smaller buildings. A second Methodist church formed, its State Street church demolished in 1961. Tabernacle Baptist opened in 1870. The Dutch Reformed congregation, in order to become a more "popular church," voted to affiliate with the Congregationalists. Some members of the old congregation sued to remain separate but lost their case in the court of appeals, and the Congregationalists took over the building on West Buffalo Street. The number of Roman Catholics reached one thousand, and there were some Jewish residents, a component of the community not present earlier, although in 1856, when faced with the coincidental deaths of three Jews passing though Ithaca—a mother in childbirth, and then a man—a portion of the city cemetery was designated the "Jewish Section."

In August 1871, fire again raged in the village. This time it began in a lumber works on Aurora Street at the edge of Six Mile Creek. Fueled by wood and wood chips, it spread rapidly down the side of the creek, consuming a barn, several carpenter shops full of flammable materials and livery stables. The newly constructed Ithaca Hotel on Owego at Tioga Street, filled that night to capacity, was totally destroyed. Guests fled as the fire raged along the street, joining shopkeepers who raced to save as much inventory as they could carry away. The "whole population of Ithaca seemed to be in the streets," reported the newspaper. George A. Johnson's barbershop was "no longer a sweet smelling saloon, but red flames rushed angrily over hair-invigorators and lather brushes." The inferno quickened, jumped Tioga Street and raced down Green with a terrible roar. As "clouds of cinders filled the air, gone in minutes were a tannery, lumber works, foundry, machine shops." It is somewhat surprising how much fabrication was taking place downtown; afterward, most manufacturing shops moved into the West End. Unable to fight the fire with local equipment, Ithaca sent to Owego for help and, at 2:00 a.m., two of its new steamers arrived on the railroad. Firefighters finally stopped the flames on Green Street, but the newspaper reported that the "upper part of town was in ruins." In all, eleven buildings burned, there were fifteen homeless families and the value of what was lost was close to $200,000; insurance covered less than half. Once again, many people had been eager to help, while others fled in alarm and some watched. During the nineteenth century, fires threatened and changed American cities—two months later, Chicago burned. There was no resident artist in Ithaca this time to memorialize the inferno.

The reaction to the fire was a general outcry about inadequate equipment, lack of available water and an "illiberal policy heretofore pursued in regards to the means of controlling fires." In response, the village created the Ithaca Fire Department and ordered two modern steam engines. Within a year, one of the new engines proved to be too heavy for the wooden bridge over Six Mile Creek, falling through the girders and killing one firefighter and injuring others. The fire department ordered better equipment, and new steel bridges replaced the older, rickety spans.

Into the Twentieth Century

Ezra Cornell lived long enough to see the results of his benevolence. He had changed the village. He predicted that someday there would be one thousand students at Cornell; he knew the library on Seneca Street was well used and that both these institutions were points of pride for Ithacans. Did he know how important these new institutions would grow to be? I suspect he understood that he had, as he had hoped, used "this Large income, to do the most good to those who are properly dependent on [me]—to the poor and to posterity."

The library's collection grew, and its great room provided a venue for cultural and university events. The university attracted students, brought faculty to town and provided local employment for many different sorts of workers. When Ezra Cornell died in 1874, the community mourned his passing. His funeral was conducted at the Unitarian Church, established in Ithaca in 1865, with a "series of preachings," a direct consequence of the university's dedication to nonsectarianism, which, to some, seemed closer to "Godless-ness."

The changes in Ithaca over the next years can be charted on the detailed map of 1866 and two bird's-eye views, one created in 1873 and the other in 1882. The 1866 map shows Ithaca as a small town served by steamboats on the lake and the Cayuga branch of the Delaware, Lackawanna and Western Railroad. The fairground was located on Lincoln Street (then Railroad Avenue). There were mills for grain and paper along Fall Creek and a flour mill near Linn Street on Cascadilla. There was a linseed oil mill on East Hill. There were only two houses on University Avenue north of the cemetery, and the rest was farmland. There was some manufacturing and a brewery on Six Mile Creek and a sash and blind factory at the inlet. There was a foundry at the corner of Cayuga and Green streets. The commercial center of Ithaca in 1866 was located along Owego Street. The post office had moved from the Colonial Building (on the Commons today) to the Cornell Library, where its rent contributed to the support of the library.

In 1873, Oakley H. Bailey and Thaddeus M. Fowler created the first bird's-eye view of Ithaca. It was drawn looking at Ithaca from the east. The house roofs seem to blur together, but the drawing depicts the placement of features on the 1866 map and shows

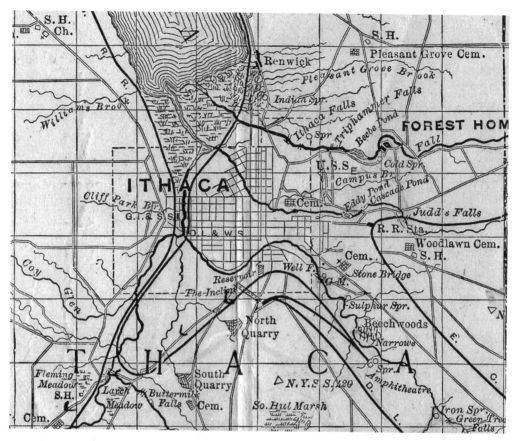

An 1875 map of Ithaca showing the extent of swamp south of Cayuga Lake. *Courtesy of the Map and Geospatial Information Collection, Cornell University Library.*

the streets lined with trees. Cornell's home, Llenroc, is drawn in, and the stone university buildings rise at the top of East Hill. This view depicts local mills, factories and homes.

The 1882 bird's-eye view created by L.R. Burleigh is drawn from the west. Each of these views is a wonderful document depicting the inlet, gorges, Ithaca's uphill topography, manufacturing and business districts and homes spreading out within the village. Both suggest the range of architectural styles found in Ithaca, and both illustrate why Ithaca was often called the Forest City. What might be most striking about each view is the extent of open land within the city and east and north of the university. The 1882 view locates a racetrack south of Meadow Street, and it places considerable industry at the west end of State Street near the four railroad lines that crossed there. It documents the Clock Factory building on the old fairground lot, and drawn in are the double row of trees along Fall Creek, the northern line of the city. There were no buildings beyond the trees, where Ithaca High School, Boynton Jr. High School, Route 13 and Stewart Park are today.

These views, and the information in the various *Ithaca Directories* and Sandborn Fire Insurance maps, illustrate the importance of the West End, where manufacturing and shipbuilding occurred. There were canalboats, lumberyards and train lines. From that

An 1873 bird's-eye view of DeWitt Park, the Episcopal Church and Ithaca Academy (across the street), and along East Mill (Court) Street, the Presbyterian church, courthouse and jail. *Courtesy of the Map and Geospatial Information Collection, Cornell University Library.*

This 1882 bird's-eye view of Ithaca shows DeWitt Park with elegant pathways and nearby buildings, including the academy and adjacent churches and homes. *Courtesy of the Map and Geospatial Information Collection, Cornell University Library.*

era, the Lehigh Valley House, the brick factory and a few other buildings survive. There were several hotels, restaurants, brothels and fragile housing that required nightly visits by the police force, then composed of a captain and four policemen.

What these two views also allow us to see is the increase in the number of houses that might be called mansions near the center of Ithaca, and the role of the railroads that brought coal, hauled lumber and other goods and delivered passengers to Ithaca. There were railroad tracks, bridges, trestles and railroad sheds. This era of the 1870s and 1880s is the pinnacle of Ithaca's role as a transshipment point. For two decades, rail transport and manufacturing also flourished in Ithaca, but this would not last. In the 1880s, there were only three railroads serving Ithaca. Franklin F. Elliott, stockbroker, was selling "R.R. Stocks," however, from his office on Owego Street. He promised, "You can trade in 10 Share lots of Stocks or 1000 of Grain or Oil, on a margin of $10.00." Investing was risky, and much of what Elliott had for sale were probably shares in western lines, a drain on the local economy. Ezra Cornell had lost a great deal of his fortune in rail stock in the crash of 1873.

The Sandborn Fire Insurance maps provide additional information. These very precise maps show each building on a lot and all the outbuildings. They provide a level of detail that is stunning. There were at least four sets of Sandborn maps made of Ithaca, drawn in 1888, 1898, 1904 and 1919. Those from 1888 appear here, expanding what we can learn about Ithaca in the latter part of the nineteenth century.

State Street was home to a variety of shops, with small factories nearby, as seen in this 1888 Sandborn Fire Insurance map. *Courtesy of the Map and Geospatial Information Collection, Cornell University Library.*

The Versatile Mr. Stewart

Ithaca's growing population, and its role as a destination and university town, heightened its need to improve its appearance. Residents and visitors required better roads with better surfaces, sidewalks, a sewer system, potable water and improved fire protection. All this put pressure on village government. There was also the need for greater accountability on the part of village administration and a better system of voting for village officials. Ithaca, long a county seat, was now home to a major university, and while Cornell provided some economic stability, its presence also highlighted the village's deficiencies.

In 1882, a committee began the process of transforming Ithaca from a village into a city. The governor signed the third charter submitted, when it stipulated that aldermen would be elected directly by wards and not on a general city ticket. In 1888, the newspaper proudly wrote, "The City of Ithaca. Ahem!" In 1888, David Stewart, the forty-fourth president of the Village of Ithaca, became its first mayor, and Ithaca became the twenty-ninth designated city in the state.

In the process, the board of trustees became the common council, and the mayor, with a two-year term, assumed broad powers of appointment. The mayor appointed commission members and city officials, such as the city clerk, attorney, chamberlain and fire commissioners, as well as the police commissioner, which became a difficulty in 1945, when the elected mayor was also the owner of a business that sold alcohol. Without being able to serve in both capacities (in which case he would police himself), he stepped down as mayor. The charter divided the city into four wards, each with two aldermen making up the common council. In 1908, when revising its charter, the city added a fifth ward. The charter of 1888 also called for municipal improvements costing more than $1 million, and with contracts put out to bid, the political parties contested all the more avidly for office.

David Stewart was a farmer, cigar maker and grocer. He was also a Mason, Odd Fellow and a member of a volunteer fire company. Most of the presidents and the early mayors shared these same affiliations, gaining leadership skills, contacts and community understanding through business, organizational connections and close affiliation with a political party. Stewart was a Republican and a member of the Town and Gown Club, where he played euchre.

He ably negotiated the greater demands of office by becoming an activist mayor, even though there was some opposition, even from members of his own party, to some of his initiatives. Charged with paving the streets and developing a sewer system, Stewart insisted, though without effect, that the sewers should be dug before the road surface was laid down. Others, who were more anxious to improve the appearance of the city and open land for development, won the day, and for some years thereafter the bricked streets were torn up so that sewers could be constructed.

In some things, Stewart led successfully. He urged the opening of Factory Street (named, that year, Stewart Avenue for him) and oversaw the erection of an iron bridge to span Cascadilla Gorge. This promoted development on streets that branched off Stewart Avenue on which landowners built fraternities, boardinghouses and some private homes. Nominated for a second term as president by the Republicans, Stewart sensed that his

This Jefferson Beardsley photograph of West Green Street is from William E. Griffis, *Art Work of Tompkins County* (Chicago, 1896). *Collection of the author.*

desire to continue public improvement projects was not shared by those who feared the growing debt. He declined to run.

Ithaca expanded to accommodate new residents and industry, pushing out from the center to convenient nearby locations, and then, around the turn of the century, Ithaca reached up the hills.

SOUTH HILL

From the start, storeowners, bankers and workers looked to lower South Hill for homes because of its easy access across the bridge at Aurora Street to the downtown business area. South Hill contained several grand homes along the Ithaca–Owego Turnpike and smaller tidy houses, many depicted on Henry Walton's (1838) view from South Hill and on the 1866 map of Ithaca. They filled the area along Aurora Street as far as Pleasant Street. There were also farms and pastureland on South Hill from which produce was brought into the village. The 1883 bird's-eye view of Ithaca depicts an increased residential population on lower South Hill between Hudson and Aurora streets. In 1867, the village renamed the Ithaca–Owego Turnpike Hudson Street, most probably in anticipation of the celebration of Henry Hudson's first voyage up the Hudson River in 1608. Hillview began as Mechanic Street, adjacent to the railroad line. Its name was changed in 1919.

A view of South Hill. *Digital scan provided by Bill Hecht, 230/23005.*

WEST OF THE DOWNTOWN CORE

In 1832, Simeon DeWitt had seen the need to provide additional attractive residential areas in the village, but extending north to the lake was difficult because of the marsh. To provide a focal point for new homes, and to encourage sales, he drew in Washington Park and added adjacent streets, but the sale of lots was slow. On the 1866 map, there were only six houses facing the park: three on Mill (now Court) Street, two on Varick (now Park Place) and one on West Buffalo. Richard Varick DeWitt, Simeon's son, later claimed ownership of Washington Park and a few of the nearby streets north of the park. The courts eventually ruled against him, giving the city title. DeWitt lived out his life as a hermit in a shack behind a home on North Albany Street—now a parking lot for Calvary Baptist Church. Until his death, DeWitt was seldom seen but much talked about, a mysterious character visited from time to time by his wealthy relatives, who arrived in a handsome horse and carriage, much to the astonishment of the neighborhood children.

Rather than live on Washington Park, several prominent Ithacans—a steamboat captain, a businessman and the prominent Treman family who moved from Trumansburg to Ithaca in 1849—built the "Gray Ladies," three Greek Revival homes on North Geneva Street. The corner "lady" was later demolished to make way for a service station. This area was close to downtown and near the village school on North Albany Street. The map of 1866 shows a line of homes along Seneca and Owego streets almost all the way to the inlet, but there were few houses west of Cayuga elsewhere.

In *The Cliff Hangers* (1961), Janet O'Daniel described Geneva Street as edged by "stately shade trees" and the area as the "old, dignified downtown section, where there was still considerable elegance." These large homes attracted other, later residents who

An 1896 photograph by Jefferson Beardsley of Washington Park with its bandstand, from William E. Griffis, *Art Work of Tompkins County* (Chicago, 1896). *Collection of the author.*

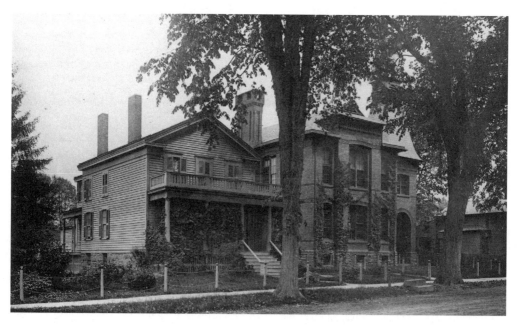

The parochial school opened in 1883 on West Buffalo Street. In the 1920s, it had an enrollment of 530 students, from William E. Griffis, *Art Work of Tompkins County* (Chicago, 1896). *Collection of the author.*

erected Italianate and Queen Anne houses. Around them there were homes built for working-class folks that are smaller, of plainer architecture, but appreciated for their closeness to downtown business, to Washington Park and to the school.

Central School was the only public grammar school until 1870, when the board of education erected the Fall Creek School. Other grammar schools came into existence after the state enacted its educational reform act of 1874. East Hill School opened in 1881 and South Hill in 1907. Central School burned to the ground in 1912 (the same year the high school burned) and was not replaced until 1923. In 1972, when the new junior high schools Boynton and DeWitt opened, Central School moved into the junior high building next door, renamed the Beverly J. Martin Elementary School. Martin, a native Ithacan, attended Central School and was the first African American to become a school principal in Ithaca. The Central School building became home to the Greater Ithaca Activities Center, providing a range of neighborhood services, and today it is an important point of community interaction.

The Sisters of St. Joseph from Rochester acquired land west of Central School and, in 1885, established the Immaculate Conception School and their own small convent in 1899 near the church. That school burned down in 1946, and three years later the diocese built the new school. The convent is now the home of Catholic Charities.

THE INLET

There has always been a mixture of small industries at the inlet, close to rail and boat transport. Many of the small factories contributed to the building of canal- and other boats, for a time a major industry. Along the inlet, there were storage sheds, coal piles and

A canalboat on the inlet, from the *Ithaca Journal Centennial Number, 1915*.

lumberyards. A place of business, the inlet connected Ithaca to the Erie Canal and then to the railroads. It was also a fascinating place for boys, who learned to swim from the docks and rode out to the lighthouse for adventure. Lou Fendrick, in his memoir *A Boy's Will…A Man's Way* (1978), wrote that "we would ride our bicycles down the road between the Inlet and the old city dump." The road ended at the pier, a "concrete construction about five feet wide and about 500 feet long, and about four feet above the normal lake level." The white lighthouse was a navigation marker for the inlet channel. The boys could see the old wooden city sewage pipes that once emptied directly into the lake.

Along the inlet, and extending beyond to Floral Avenue and the city line, was a section of Ithaca called the Rhine, apparently named that by a member of the Cornell crew with a romantic imagination. In this area was Silent City, a collection of "drifters, poachers, and canal people," who lived in flimsy housing without title to the land. There is a good deal of lore about the Rhine and the people who lived in the area. The lives and the conditions under which they existed were hardly romantic. The people of the Rhine lived precariously, with little hope of moving to anything better. Janet O'Daniel, who grew up in Ithaca, described one residence as a "good roomy tank, still smelling strongly of gasoline, but nonetheless tight and sound, and large enough so that one could sit cozily in it, and stand with only a slight stoop." Fixed up with bits of lumber found nearby, O'Daniel's fictional characters had a small stove, a bed, a cooking pot, plates and cups. Light came from candle scraps. The people in the inlet had little security, and few had steady jobs, living instead by poaching fish or hunting rabbits. They were dreadfully poor and resentful of the lives of ease that others took for granted.

Grace Miller White grew up near Hayts Road and used Ithaca's Rhine or Silent City as a setting for several of her eleven novels. White's Ithaca stories usually feature poor

"On the Rhine, Ithaca Inlet, NY," original drawing by Reynolds Beal, 1888. *Collection of the author.*

motherless girls raised in poverty, an insistence that promises always be kept, threats to the heroine that are thwarted at the last moment and the young women loving, wisely or not, men who were more fortunate. The stories highlight class divisions, setting Tess or Polly or Judy against the hypocrisy of unchristian ministers, crooked lawyers and snobs who lived comfortably but lacked nobility of character. Boys from the Rhine in White's novels did not climb the economic or social ladder, though each of White's heroines manages to find happiness after sinners and the unjust receive their comeuppance. In her 1901 novel, *Tess of the Storm Country*, White depicts the squatters' world as squalid and resentful: "When they glanced up from their work they could see, rising from the mantle of forestry, the towers and spires of Cornell University in Ithaca City." They looked with a "hatred" that would "pass unconsciously over their faces as their eyes lighted on the distant buildings." In White's books—and probably in real life—the residents of the city looked back with equal disdain. Laws about taking game and fish compounded the severe weather that sealed "the lake with thick ice" and took their toll, while the squatters "faced the bitter cold and frozen surroundings with stolid indifference."

Lou Fendrick was well aware of the reputation of Silent City and the many stories about what went on there. "We heard of people who dared to go to the swampy area and were never heard from again," he wrote. "Drifters, poachers and canalers were residents, and anybody wanted by the police could find refuge in Silent City." In 1927, the Department of Public Works relocated everyone living along the Rhine "in some other part of town" and burned the squatter shacks. But Fendrick observed, the "Rhine still existed" in the memories of those forced out. It exists still in the movies made from White's novel *Tess*, in local lore and in the documentary films created at Ithaca College. There are residents of Ithaca today who ascribe their origins to the Rhine.

THE PIE-SHAPED PIECE

The regularity of Ithaca's street plan, ordained by DeWitt, is broken in a wedge of land where the streets run northwest instead of true north. This piece lies west of North Cayuga Street to the numbered streets, Second, Third, etc. In recent times, Northside designated the area along North Cayuga Street, where a popular pharmacy and liquor store were located, although the liquor store is now located on the Southside. The fairgrounds were once located at the top of the narrow slice, later replaced by the Ithaca Calendar Clock Company and the Audophone Company when the fairgrounds opened in 1875 southwest of Ithaca (where Tops and Wegmans are today). The Clock Company was quickly surrounded by homes for workers and those who labored in nearby companies. When I tracked where Clock Company workers lived during a period in the late 1870s, all of them registered in homes nearby, except for one, who had an address on South Hill. The clock factory produced six thousand clocks annually, but by the end of the century its operations had ceased. The Ithaca Organ and Piano Company, begun in 1877, was considered a complete failure by 1885, and the Ithaca Audophone Company, founded in 1877, and popular for a time, manufactured organs and music rolls. By 1925, it had collapsed, and the craze was over.

A view of the first fairgrounds, located at Dey and Adams streets, from the *Ithaca Journal Centennial Number, 1915.*

This 1888 Sandborn Fire Insurance map shows the Ithaca Calendar Clock and Audophone factories on the first fairgrounds. *Courtesy of the Map and Geospatial Information Collection, Cornell University Library.*

There was slow development in the triangular area, although worker housing was erected along Auburn and Dey streets. The western slice of the pie from Cascadilla Creek was totally without housing north of Hancock Street in 1866, and it grew only slowly afterward.

The Ithaca Gas Light Company built its headquarters in 1852 at Court and Plain streets and became a major employer. In 1918, the company became part of the New York State Electric and Gas Company and left its brick building, which was used as an alternative junior high school in the 1960s. The Depression of 1873 staggered local workers, many of whom lived in this area closest to Cayuga Lake. "Do the laboring men of Ithaca who walk the streets day after day," asked the *Ithaca Democrat*, "seeking work and finding none, and who at night go home tired and discouraged to their half-starved families, agree with the Ithaca *Journal*" that the "times are all right?" The short-line railroads failed, or they were bought up and organized by the Lehigh Valley Railroad. Railroad history is told in an updated edition of Hardy Campbell Lee's *A History of Railroads in Tompkins County* (1977).

There was some new industry. Ezra Cornell established the Ithaca Glass Company in 1874, which expanded into a five-building complex on Third Street. In 1882, two new glass companies were built along Railroad Avenue, as was a stoneware company. Empire Glass was bought out in 1889, however, and the Washington Glass Company produced window glass until it ceased operation in 1892. These glass factories operated during the winter months, as the summer was considered too hot to maintain the blast ovens, and many area houses were rented on a ten-month lease. What I have been told is that, in the summer, the glass workers and their families moved to the lakeshore, where they lived in tents erected on platforms, thus accounting for some of the narrow lakefront parcels close to the city.

In all, Northside was a mixed-use neighborhood, though by the 1920s most of the larger factories had totally disappeared. Factory sites and the rail yards were playgrounds for local boys, who took over any empty lot, erecting trapeze bars and rings in the trees and playing football, baseball and war games in the fields.

FALL CREEK

Fall Creek was annexed by the village in 1826, but it did not prove attractive to homeowners until well into the 1860s. Fill helped stabilize the ground for home construction, and the village put in roads. Even so, the area was not safe from the inundations by floodwater, and wet basements were common. Although Ithaca's early plans showed streets throughout Fall Creek, they were built only as the area became popular with homeowners. In 1866, there were only fifteen houses between Tompkins and Jay streets, in addition to the cluster of worker homes at the base of Ithaca Falls.

After 1870, skilled workmen and laborers, along with some small business owners, moved into Fall Creek, only a short walk to the center of the village or to the factories to the west. Many people earned their living as grocers, cigar makers and shoemakers, and some established themselves at home, tinkering in carriage houses, blacksmithing in small sheds

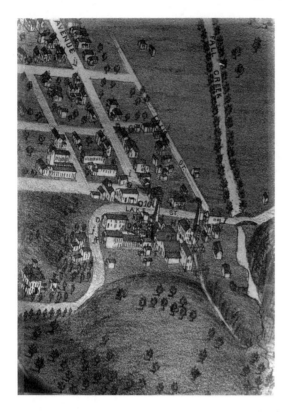

A bird's-eye view of Fall Creek, 1873, showing factories clustered along Lake Street. *Courtesy of the Map and Geospatial Information Collection, Cornell University Library.*

or offering homemade goods and some staples for sale. Near the end of the century, the population consisted of tradesmen and their families. Amy Humber reported that James Colbert ran the last corner store in Fall Creek, keeping his doors open until 1971.

The decline of small neighborhood shops accelerated during the first half of the twentieth century until, today, few remain anywhere in the city. In Fall Creek, there is a restaurant and movie theatre, due to close in 2009, the Lincoln Street Diner, a laundromat and a few other businesses. The patterns of how we shop have altered, as have our needs. Those small commercial enterprises depended upon having someone home to "tend the store," which happens less and less these days as many adults are employed outside the home. Those small home businesses are, for the most part, gone, unless we consider the large number of talented writers and painters who have moved in along North Tioga and adjacent streets, making Fall Creek, as one real estate person said to me in 2008, "the new hot neighborhood."

Many of the houses in Fall Creek are three-story wooden buildings that appeared after the establishment of the local fire company. Founded in 1863, the Cataract Company No. 7 moved several times, including to a building that burned down in 1884, and eventually located on North Tioga Street. It is now a private residence and artist's studio. The Cataract Hotel, its name taken from the Ithaca Falls, was a popular destination. It functioned from 1890 to 1915. Patricia Pesoli-Bishop, who grew up on Falls Street, considers the waterfall the heart and soul of the neighborhood, especially for nearby families. She wrote that "it wasn't just a magnificent waterfall, it was the backdrop, the

constant sound and sight of the neighborhood," and it served, much as Washington Park did for the area west of Cayuga Street, as a focal point for community interaction. Into the twentieth century, the waterpower, first tapped at the beginning of the nineteenth century, was still a factory site. Pesoli-Bishop recalls that the "Ithaca Gun Company and the Paper Mill, were an ever-present part of the neighborhood."

The Line at Clinton Street

Until 1866, there was no development south of Clinton Street between Albany and Meadow streets. That was the land Abraham Bloodgood had reserved for himself and then sold in 1868 to Charles Titus for development. The tract was subject to frequent flooding. Titus established a few streets and blocked out North and South Titus, which by the 1920s were considered beautiful tree-lined boulevards, but he had little luck selling lots until after 1871, when he built a large, imposing, three-story home for his brother-in-law, Joseph Sprague. For some years, the Sprague House sat alone on a city block of tended lawns and gardens. In the next decade, the tract began to attract builders and residents.

West of Six Mile Creek there was little activity until after 1900, when Andrew Hyers built ninety houses (between 1904 and 1929). Each sold for $2,500, requiring a down payment of only $100 and a mortgage payment of $25 a month, making home ownership possible for working people. In 1905, on the rise of West Hill and overlooking the inlet, the Ithaca Reality Company developed 106 building lots on and around Hook Place. In the 1920s and '30s, Leon H. Cass improved additional residential lots on West Hill.

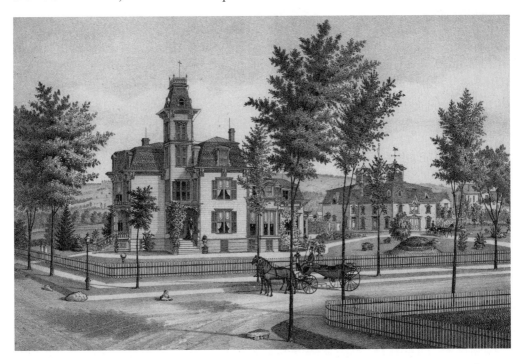

The residence of J.B. Sprague, North Titus Street, showing the extensive grounds, from *History of Tioga, Chemung, Tompkins & Schuyler Counties, New York* (Philadelphia, 1879).

CROWN OF CAYUGA

Ithaca was sometimes called the Crown of Cayuga. That title aptly fits Stewart Park, which began as Renwick Park, used and loved by generations. That lakeshore was part of Military Lot No. 88, granted to Andrew Moody in 1790. He sold his parcel to James Renwick, and the tract remained in his family for 104 years. In 1894, the Renwick Park Association of Ithaca negotiated to buy the lakefront acres. The trolley company extended a line to the newly opened Cayuga Lake Park, making it a popular destination, with a merry-go-round that delighted children, band concerts twice a week during the season and a group of monkeys on display in a cage. At one time, a popular restaurant was in operation at the park. Renwick became a major site for public entertainment, an important intersection of residents and tourists. As work began on the Cascadilla boathouse, events at the park were promoted in a regular newspaper column. The park featured electric lighting, pavilions, swimming in the summer and ice-skating in the winter.

In 1906, Jared T. Newman paid $3,540 for land on the east side of the inlet, believing "that it would ultimately be advantageous for the city to own the tract." A parcel of eleven acres containing a string of boathouses on the inlet sold for $5,776. The trustees added 18.1 additional acres, now the Louis Agassiz Fuertes bird preserve, and 88 acres on the west side of the inlet.

In 1921, when Mayor Edwin C. Stewart died in office, he left the city $150,000 to develop the park, which was named for him. In 1923, the city purchased the boathouse, and in 1925 Henry St. John added more land along the lake. WPA (Works Progress Administration) workers improved the park in the 1930s. Stewart Park, the City Golf Course, the Fuertes Bird Sanctuary, the Alan H. Treman Marina along the inlet, the original airport, now the Hangar Theatre, and the walking trail along the inlet are pearls in the Crown of Cayuga.

MR. EGBERT'S VISION

W. Grant Egbert, a Danby native, created the Ithaca Conservatory in 1892 stating that he would "build a school of music second to none," as apt a motto as that of Ezra Cornell. Egbert sold shares in the conservatory to Ithaca residents that entitled holders to receive instruction and attend concerts, the first given in the early Unitarian Church. Instruction began in four rooms at 403 East Seneca Street with eight teachers and two lecturers. In addition to violin, keyboard instruments, banjo, mandolin and guitar, there were classes in French, German and even fencing. At the end of the first successful year, more space was needed and, gradually, instruction moved into the Wilgus Opera House above Rothschild's Department Store on State Street. The new Lyceum Theatre (1893) provided adequate public stage space for many years. When the conservatory expanded, requiring additional space for its programs and students, it moved into buildings around DeWitt Park, turning the park from time to time into performance space and filling it with students.

The corner, now the Commons, was the center of activity. Note the Ithaca Journal building on South Tioga, from William E. Griffis, *Art Work of Tompkins County* (Chicago, 1896). *Collection of the author.*

Several prominent Ithacans, who were impressed with Egbert's vision and the addition to Ithaca's cultural life, incorporated the Ithaca Conservatory. The first graduation occurred in 1897. As the conservatory grew, though not without financial pains along the way, it added new programs. The Williams School of Expression and Dramatic Art began in 1897. In 1901, the Conservatory Home for Lady Students opened at 312 North Geneva Street. Over the next decade, there were several "Affiliated Schools": the Ithaca Institution of Public School Music (1912), the Ithaca School of Physical Education (1916), the Martin Institute of Speech Correction (1918) and the Conway Military Band School (1921), led by Ithaca's colorful "Patsy" Conway, who drew musicians to the community and gave wildly popular concerts every summer, some in town and some at Stewart Park. Downtown Ithaca became a hub of musical and dramatic shows created by faculty and students at Ithaca College.

Up and Out East Hill

It was the success of Cornell that pulled residents up East Hill, which had only been settled to the rise of Brimstone Hill, with Eddy's Mill and a handful of houses perched

at a crest at the end of Eddy Street. The mill tapped water from Cascadilla Creek, and workers lived nearby rather than negotiating the hill several times a day. College students walked up and down, however, sometimes several times a day, for in the town there were bookstores, restaurants, tailors, pharmacists and general merchants. For a brief time there was a horse-drawn omnibus, but after 1884 the trolley traveled to the campus and looped back down again.

It was not until the turn of the twentieth century that Collegetown became an informal extension of the university. That followed the construction of Eddy Gate in 1896, donated by Andrew Dickson White and known as Andy White's Chocolate Layer Cake because of its striated limestone blocks. An elegant stone bridge replaced a wooden bridge built in the 1870s. As late as 1900, *The Ithaca City Directory* only listed one barber in what is today Collegetown, one restaurant, a tobacco shop, two laundries, a grocer, a men's furnishing shop and two tailors—not many services for an expanding student population. Some faculty rented or built on East Hill, although many lived in houses on university land in the midst of the campus.

There were dangers on East Hill. While women at Cornell were required to live in university housing, men found places in fraternity houses or in boardinghouses. These were not run in a particularly sanitary way, which Martha Van Rensselear and Flora Rose, directors of the home economics program at Cornell, pointed out in 1912. There was often overcrowding in the lodgings, where some students had inadequate heat and light. The greatest danger, however, was from fire, and especially vulnerable were the early fraternity houses. In 1899, the Kappa Alpha house burned. In 1900, the Delta Chi house went up in flames. In 1906, the McGraw Fiske mansion, then home of the Chi Psi fraternity, located at the edge of campus burned, with a loss of seven lives, brothers and firemen. In 1907, an extensive fire in Collegetown destroyed a number of buildings. In 1911, the Sigma Alpha Epsilon fraternity burned. In each case, getting fire trucks up the hill proved to be difficult. In 1895, a group of students and faculty established the Neriton Fire Company No. 9, now the Nines, a popular hangout, named for a high point over on ancient Ithaki, in Greece. The Cornellians in the fire company were making an analogy between the high spot on East Hill and Neriton, the "mountain/Leaf quivering Neriton, far visible," of *The Odyssey*, just as Simeon Dewitt had done earlier when he named his planned city Ithaca, set within the Town of Ulysses.

A view of East Hill in 1879, showing Cornell University buildings at the top, from the *Ithaca Journal Centennial Number, 1915.*

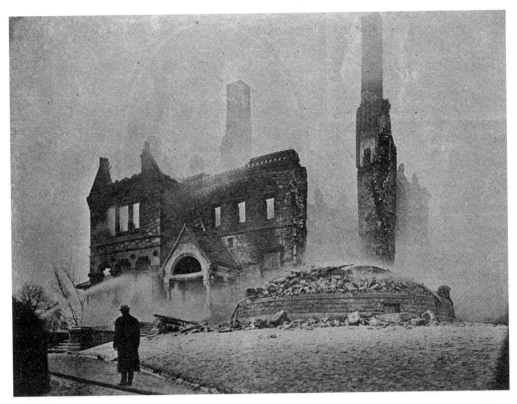

The Chi Psi fraternity house burned down on December 7, 1906. Four students and three Ithaca firemen lost their lives, from the *Ithaca Journal Centennial Number, 1915.*

"GRANDEST AND BEST"

There were few houses for Cornell's faculty and staff near the university. The trustees allowed some faculty to build homes on campus, but space was limited, and by the mid-twentieth century, those homes were gone. Others eyed the farm fields east of Cascadilla Gorge and north of Fall Creek, where there was potential for residential growth. In 1897, Edward Wyckoff, a wealthy investor involved in a number of enterprises, bought the land along Fall Creek Gorge, declaring it the "grandest and best in this country." He hired a planner who departed from the grid system of the streets below and developed Cornell Heights, with Fall Creek Drive following the curve of the gorge. In 1901, Wyckoff's Cornell Heights Land Company bought sixty-eight additional acres, setting aside land for the Ithaca Country Club, founded in 1900. He also bought an interest in the Ithaca Street Railway Company and spanned the gorge at Thurston Avenue in 1898 with a Groton Bridge. Wyckoff built a grand home for his own use and offered residential lots for sale. He also built a few houses on speculation. In 1903, in lieu of paying taxes for fifteen years, Wyckoff transferred ownership of the streets and bridge to the city. Faculty families were attracted to Cornell Heights, as were city residents wanting a more bucolic life in what was considered more healthful country air. By 1915, Cornell Heights

The Ithaca street railway system was chartered in 1884 and stopped running in 1935. This map is from the June 16, 1906 *Ithaca Daily Journal.*

was a mixed residential neighborhood of faculty, renters, fraternities and residence halls. It featured easy access to the university and, once the trolley crossed the gorge, to downtown.

EAST OF CAMPUS

On the east side of campus, along Owego Street and Judd Falls Road, James Mitchell bought land originally deeded to the Pew family. He built his home on what became Mitchell Street and farmed nearby. In 1865, the hilly section along Judd Falls Road became Mount Olivet Cemetery. The Driscoll family, contractors and builders, owned land along East State Street, an area that came to be called Irish Nob—"nob" for hill, or possibly a shortening of the word "nobility"; perhaps both meanings were true. In 1871, the Elmira, Cortland and Northern Railroad bought the right to lay tracks through the area to the East Hill Station.

Eyed by everyone looking for a home near campus was the land directly east of Cascadilla Gorge and north of Collegetown (between Mitchell Street, south of Oak Avenue and east of Linden). This farmland belonged to Solomon Bryant, who was "not in sympathy with higher education" and would not sell lots to anyone. His children were not so scrupulous and, upon their father's death in 1908, created the Bryant Land Company to develop a forty-five-acre tract divided into 161 building lots. In the process of creating streets, three triangular green spaces were left; two remain today as small city parks. By 1918, there were seventy single-family, two-story homes inhabited primarily by faculty and staff at the university. Carol Sisler has described the importance of this surge of home building to the local economy. She observed, in a fine essay included in *Ithaca's Neighborhoods* (1988), that

lumber came from the English Lumber Yard on Cornell Street, shingles and firebrick from the Driscoll Brothers, fixtures from Davis-Brown Electric, brick from Robinson & Carpenter, hardware from Treman & King, tin roofs from Barr Brothers, and paint from C.J. Rumsey & Company.

With homeowners, as well as students nearby, merchants found Collegetown increasingly attractive, and many established additional services in the area. Rym Berry, Cornell director of athletics and local commentator, bemoaned the development of Collegetown, however, because it offered more of the things that students needed, and, consequently, their connection with downtown residents and merchants lessened. That separation became even greater over time, with many Cornell students having little need to visit downtown Ithaca at all. Today, Collegetown, which has experienced tremendous growth with high-rise student apartments, has become home to an expanding population. Density, parking and development pose continuing planning challenges for the city.

BECOMING MODERN

Some technological innovation was pioneered in Ithaca and some came from outside. William A. Anthony, professor of physics at Cornell from 1877 until 1887, was both resident genius and entrepreneur. In 1877, Anthony received permission from Alexander Graham Bell, who demonstrated a successful telephone the year before, to stretch a wire between the university and the town. With local supporters, he established a "Bell" Telephone Company. It was in Ithaca that selective ringing began, eliminating the need for each call to ring at every instrument. In 1880, the *Ithaca Journal* crowed that "the telephone exchange has obtained its hundredth subscriber," a high rate compared to the overall population.

The popularity of the telephone might have stemmed from its low cost or from the willingness of the "people of Ithaca to appreciate and avail themselves of the advantages offered by new inventions." It is probable that the telephone's popularity was also due to the university's location at the top of the hill and that the trip downtown, even by trolley, was tiresome and time consuming. The telephone, as had the telegraph, from which Ezra Cornell derived his wealth, speeded up communication. By 1882, the New York and Pennsylvania Telephone and Telegraph Company bought out Anthony and his partner, Wyckoff. The New York Telephone Company obtained control of phone service in 1909, but for a time there were two systems, the "Ithaca" and the "Bell," and local lore suggests that some people maintained two instruments.

In 1880, Professor Anthony also pioneered outdoor lighting. He created an arc light by stringing a wire between McGraw Hall and Sage Chapel. Imagine what a sensation it must have been to look into the dark night sky and see a light where one had never been. Anthony extended this outdoor lighting system across campus and installed electric lights in the university library, something President White regarded as a novelty. He thought students would soon tire of going to the library after dark!

The benefits of electric lighting were obvious, and in 1884, a group of local men incorporated the Brush-Swan Electric Light Company of Ithaca to furnish seventy

streetlights on what was called the "moonlight schedule"; that is, the lights would not come on when there was supposed to be moonlight. This system often left Ithaca's streets dark, for, even when it was functioning, it switched itself off at midnight. Ithacans routinely grumbled about the dark streets, and an article in the *Ithaca Democrat* complained that "we pay more for street lights than any other town in the state." In 1887, our resident innovator William Anthony decamped from the university to take a better-paid position in industry.

Few industries in Ithaca were able to withstand national trends of amalgamation and consolidation, and many of the small factories begun in the 1870s and 1880s disappeared. The glass companies that lasted until 1898, and other Northside industries, were gone by 1900. In *Emily: A Tale of the Empire State*, a 1894 novel set in Ithaca and written by Clara Loring Bogart, the young male hero explained the loss of a brickyard, stating, "Probably it is no longer profitable. The new brick machines can turn out brick so much faster than those antiquated affairs, that I dare say they did not pay expenses." And so it was for local factories. These industries had provided employment, but getting produce to markets was always a problem, as was competition by larger, better-funded factories elsewhere. Local companies were almost all underfunded, and most could not modernize as times changed. Many became victims of industrial consolidation. The industrial era only fostered a few companies that survived to the middle of the twentieth century.

In addition, technology's promise of ease and speed always carried with it the threat of obsolescence. The few that remained were the various Morse Industries and the Ithaca Gun Company, founded in 1883 on Lake Street along the ridge of Fall Creek Gorge. Education became Ithaca's largest employer, its most stable base, for even when Cornell and Ithaca College were rocked by dire economic times—as they both would be in the Great Depression—they survived, serving as the community's safety net and setting Ithaca apart from other regional cities.

Electricity transformed local transportation, making possible a local trolley system. In 1883, a horsecar line operated from the Ithaca Hotel (at the center of the Commons) to the railroad station and the steamboat landing. In 1884, the Ithaca Street Railway Company established a trolley line, one of only thirteen in the country. Power at first came from a mill on Six Mile Creek. Then, in 1891, with new financing, power was derived from a waterwheel in Fall Creek just above the Stewart Avenue Bridge. There was question whether the trolley that functioned well on flatland along State Street could manage to scale Ithaca's East Hill. Owners of the horse-drawn omnibus and livery stables watched sadly as the little car made the trip easily and successfully, first to the campus and then, with university trustees' permission, across to the library.

Other technologies brought Ithaca from the nineteenth century into the twentieth. Unwieldy at first, the bicycle generated a great deal of enthusiasm as people learned to ride. Ithacans joined the national craze and went to see bicycle exhibitions to try out a "wheel." There were bicycle clubs and bicycle exhibitions and races. An Ithaca bicycle team competed with nearby teams. Most viewed the bicycle as a source of entertainment and amusement.

Motion picture technology, on the other hand, excited everyone. Ithaca experienced movies as they were being created and on the screen. Ithaca's setting on the lake, with

dramatic gorges punctuating the hills, its picturesque university and its students first attracted filmmakers. In 1911, a crew arrived in Ithaca to make two short films at Cornell, showing the football squad playing on Percy Field and the crew on the inlet—the "first time successful exposures have been taken of college activities." Over the next ten years, films were set at the university, in the gorges, on bridges, in fields and on, along and in the lake. The Wharton Studio settled at Renwick Park to the delight of many, calling on local people to watch the filming and appear as extras as it produced nine popular serials, according to Ithacamademovies.com. Among them were *The Romance of Elaine* (1914), *The Exploits of Elaine* (1914) and *The New Exploits of Elaine* (1915), *Mysteries of Myra* (1916) and, ending in 1920 with fifteen episodes, *Million Dollars Reward*.

In *The Cliff Hangers*, a novel about moviemaking, Janet O'Daniel depicted Ithacans as enthusiastic about the movies—and some as disdainful of the movie people who came to town. But Ithaca's sunlight was only reliable in the summer, whereas filming could go on year-round elsewhere. Moviemaking ended abruptly, with the exception of a few films made here until Irene Castle, who had come to Ithaca to make movies, married, lived here briefly and then dramatically left, divorcing both husband and community.

Even without a movie production company, Ithaca was considered a theatre town, with live performances and movie houses. The earliest movie shows were presented at the Happy Hour Theatre located in the basement of the Cornell Library. In 1911, the Star Theatre opened; in 1915, the Crescent; and in 1917, the Strand. Movie ads appeared daily in the newspaper announcing a variety of films, along with articles about the lives of film stars and discussions of movie plots.

CITY OF ITHACA.

165-X	Assessor, City	Cayuga & State
127-X	Board of Health	116 E. State
2	Chief of Fire Department	214 N. Tioga
374-X	City Attorney's Office	Savings Bank Bldg.
2-X	City Clerk's Office	City Hall
103	City Superintendent	City Hall
2-X	Mayor's Office	City Hall
281	Police Station	City Hall
283	Recorder's Office	City Hall Annex
259	Sewer Pumping Station	Franklin
103	Stewart, H. L., Supt. Sewers	City Hall Annex
103-X	Superintendent of Poor	City Hall Annex
283-X	Tax Collector	City Hall Annex
283-X	Treas. Office, Henry Carpenter	City Hall Annex

An entry from the *Directory of the Ithaca Telephone Co.*, November 1907, offering local and long-distance telephone service. *Copy in the collection of the author.*

Making movies from an open car. *From the collection of the Tompkins County Historian, 44.21.*

An 1899 photograph by Miles D. Lane of the first automobile in Tompkins County. *From the collection of the Tompkins County Historian, 2.1.*

It was overwhelming change that arrived in Ithaca in 1899, gliding in from Syracuse at approximately twenty miles an hour. A year later, there were three locomobiles in Ithaca—the Stanhope model was favored—and a number of people were considering buying an auto. The automobile surpassed all the wonderful inventions of the past half century: the sewing machine, the telegraph, the improved washing machine, the telephone, the bicycle. Perhaps only the electric light rivaled the automobile for the revolution it wrought in everyday life. Change did not happen at once but unfolded as the automobile altered the way people thought about regulation and safety, about road surface, time and distance, advertising and about the etiquette of the road. The automobile owner moved from club membership similar to that of bicycle owners to auto registration (1901), state licensing and the regulation of speed. The automobile changed the way our roadsides looked, adding signs, eventually tourist cabins and roadside stands that sold everything from jams to quilts to farm products. The auto proved to be an attractive nuisance, enticing young boys to reach in and honk the horns of cars parked along the streets or to take them for a joyride. The flivver bestowed immediate status on its driver, but drivers had accidents. The automobile highlighted the dangers of overindulgence at local taverns, and it frightened horses. The automobile speeded up life and gave people a new independence, and it altered patterns of courtship. At one time, men "called" on a lady at her home, where there was some parental permission and supervision. With an automobile, he was able to "take a lady out," planning and paying for the date during which supervision was minimal or absent. Courtship moved from the living room or front porch to the backseat.

The automobile necessitated road improvement. By 1913, there was a complaint that "it's a long road that has no potholes but in Ithaca it's just a long mud hole." Another

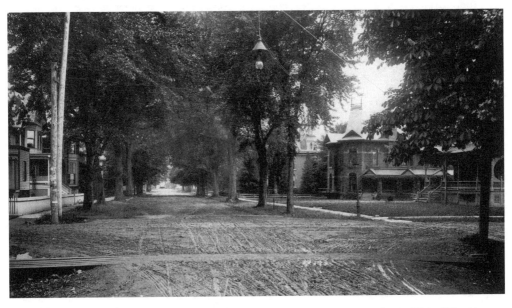

Mud and wooden sidewalks on South Albany Street in 1896, in William E. Griffis, *Art Work of Tompkins County* (Chicago, 1896). *Copy in the collection of the author.*

comment was that in Ithaca there were six-inch ruts in winter, soft mushy mud in spring and a foot of dust in summertime. Auto travel prompted beautification of the landscape; it brought about parks as destinations, required better lighting and put carriage makers out of business. The automobile created a need for road cartography and encouraged auto tourism. In 1911, the state issued three hundred auto licenses to people in Ithaca. By 1916, there were eight automobile dealers and auto repair shops in Ithaca.

No city in the country, however, was prepared to deal with traffic congestion. Ithaca's streets were never intended to accommodate lines of cars moving in opposite directions between autos parked at the curb. But automobiles were irresistible. The auto hastened doctor to patient; it was praised for its utility for getting produce to market. But a car needed to be parked, and it introduced the issue of obsolescence, since next year's model was always better, faster and more beautiful. Think of what we say about our computers: "obsolete as they come out of their boxes." In the early 1970s, computers were tools used by scientists and specialists. Today, the computer is ubiquitous. The telegraph, automobile and the computer have all changed the rates of speed at which we live; they give us access to a wider world and have become indispensable to daily life. They created status and caused envy. After the arrival of the first automobile, Ithaca would never be the same.

DESTINATION CITY

A consequence of the popularity of the automobile was the development of destinations—places to drive to—and many saw the advertising and promotional possibilities created by the automobile. Just as the trolley company developed Renwick Park as a destination to which Ithacans headed for concerts, exhibitions, public gatherings, swimming and dining, geographic places and historic sites also became popular destinations. In 1919, the Finger Lakes Tourism Bureau began promoting this region, hoping to attract auto tourists. How was Ithaca to promote itself? Ithaca had the trolley park at the lakefront and there was the university on the hill—ever popular with visitors. But what else had Ithaca to offer in the face of advertisements for places like Watkins Glen, which was already heavily promoted in railroad and innkeeper literature?

This challenge was partially answered by Robert H. Treman, a public-spirited and environmentally aware individual. In 1917, Treman offered the city land that he owned along Six Mile Creek. The *Ithaca Journal* headlined it as an opportunity to "launch [a] campaign to develop [the] city's scenic advantages," a way for the city to compete for tourist attention and to make residents aware of the unique features in their midst. Treman saw the possibility of putting Ithaca's topography to work and, at the same time, preserving it by naming and reserving land as a public trust. He was our first promotional environmentalist, and today's efforts to preserve the land follow his lead.

Treman promoted Six Mile Creek as the best gorge scenery in the region, and he hoped that creating a park would "render this tract easily accessible" as a place of public recreation. Treman made his gift in much the same way that Ezra Cornell had donated the library: both were contingent upon the public taking responsibility for upkeep and

DeWitt Park with bandstand and pathways, in William E. Griffis, *Art Work of Tompkins County* (Chicago, 1896). *Collection of the author.*

development. In Cornell's case, he turned the library over to a board of local clergy and citizens whose job it was to hire librarians and raise money for books and maintenance. Treman gave his land with the condition that it would be "set aside irrevocably for a park," open to the public, and that the city agree to maintain it "in reasonably good order." He thought Six Mile Creek would provide a "most needed and useful recreation park for all of its citizens and that it can be maintained with very little expense."

Treman proposed a scenic road through the park, flowing from Aurora Street, dipping south of the city hospital on Quarry Street and then along the creek to the water filtration plant. The road would provide access for automobiles, and from there it would be trails for hiking down to the water, where the visitor could even go "beneath the walls of the gorge itself." In Treman's mind, this unique piece of Six Mile Creek would link naturally with other features in Ithaca—the lakefront, the university, the tree-lined boulevards of Seneca Street and Titus Avenue, all sure to lure tourists to Ithaca. The focal point of this scenic highway was to be DeWitt Park, considered a place of quaint old-world character, distinctive and pleasing, "an intimate enclosure, not private and forbidding but thoroughly hospitable—the living heart of the town."

THE CITY'S ILL HEALTH

Disease presented another kind of challenge to the city, a threat to everyone. From its earliest days, Ithaca had been known for its bouts of seasonal fever: Ithaca fever, some said; Genesee fever, others called it. It was malaria distributed by mosquitoes that bred in

the swamps. Generally, its symptoms were a mild flux that some learned to live with and to which others became immune. Early in the nineteenth century, Ithaca had attempted to promote its reputation as a beneficial place to live, and from 1831 on, the board of health issued notices about the healthfulness of the area—most often after the outbreak of a disease like smallpox. One editorial entitled "Health in Ithaca," dating from 1829, countered reports that Ithaca was an unhealthy place by admitting there were "normal afflictions" in Ithaca, but not enough to cause alarm. "The sun is clear," it stated, "the temperature constant during the night." And, it was claimed, Ithaca had a "good quality of water," available to all.

The public's health depended upon a secure water system. In 1849, Henry Sage created a private company to bring pure water into the village from springs near Buffalo Street. In 1872, water was tapped at Buttermilk Creek, piped to a reservoir on South Hill and then delivered into Ithaca. In 1892, the private water company purchased Van Natta Mill Dam to increase the water supply for the growing city, and in 1893, a pumping station was added. By 1900, ownership of this private system had passed from the Treman and King families to William Morris of Penn Yan.

Not everyone, however, had access to clean water. Refuse and the contents of the early sewer system dumped directly into the inlet. Residents knew its waters were polluted, yet some—young boys learning to swim, area laborers and those who lived along "the Rhine"—used that water for bathing and even cooking. In 1892, there was an outbreak of typhoid fever, which promoted serious discussion, but no action, about the city acquiring the waterworks.

An 1896 view of Ithaca from Cornell University, in William E. Griffis, *Art Work of Tompkins County* (Chicago, 1896). *Collection of the author.*

This failure to create a public utility came back to haunt everyone in early January 1903, when a citywide sickness broke out. The city health officer insisted it was "absolute nonsense" that that there could be typhoid fever in Ithaca, but by the end of January there were 105 cases and, ultimately, more than 703 people were infected. Many went to the city hospital; others gathered for aid at the Unitarian Church. Some were treated in the Cornell infirmary. There was a plea for donations of blankets, sheets and nightgowns. What was the source of the infection? Fingers of blame were pointed variously, especially at Italian laborers working among the crews digging a new railroad bed. There was also a complaint that more time was spent "in trying to fix the blame for the epidemic than in bringing it to an end." Ithacans boiled their drinking water, but the disease persisted.

Then, George Soper, a sanitary expert, came to Ithaca in much the same way that Reverend Wisner had come in 1817, although Soper arrived on modern transport. He forged a working relationship with city officials and Cornell President Jacob Gould Schurman. Allied against the disease, they waged a campaign that engaged in "public health work of a kind seldom seen outside of a military situation." They instructed homeowners on how to clean privies, and they tested water, leading to the condemnation of more than 30 percent of local wells. They directed that food was to be inspected, and they promoted efficient removal of trash from the streets and sanitary refuse disposal. Long on the books, though mostly ignored, sanitary laws were enforced. In all, there were fifty-one deaths in Ithaca in 1903, including thirteen Cornell students. Sixteen additional students, who left Ithaca when they became ill, died elsewhere, yet no one who drank only from the separate university water system became ill, save for one young woman who was known to have dined off campus.

Ithaca underwent a general housecleaning, and new sanitary practices were put in place, but typhoid lingered in the area for the next decade, with an average of thirty-nine cases each year. The epidemic was halted by the efforts of town and gown working together. This severe challenge to the city's health resulted in a vote to buy the private water system and to operate it as a public utility. Offered to the city for $605,000, the city thought the price too high. After arbitration, the city paid $658,000 for the waterworks and another $100,000 in legal fines and fees.

What the city learned was to react to threats from disease as quickly as possible. The lesson of the 1903 epidemic was useful in 1918, when influenza struck. That national epidemic resulted in more than six hundred cases of the "grippe" in October, filling the city hospital and the Masonic Hall, Cascadilla Hall and the Cornell Infirmary. The Red Cross opened a "slow recovery hospital" for those whose illness lingered. Despite prompt action, in Ithaca there were seventy-five influenza deaths.

IF YOU FIND ITHACA POOR

Constantine Cavafy, the Greek poet who lived from 1863 to 1933, wrote a poem entitled *Ithaca* about the journey of life. There are several lines from the poem inscribed on a monument on the Commons. In the poem, Cavafy cautioned that, upon arrival, "if you find her poor, Ithaca has not deceived you." Ithaca is rich in people, community activity,

The Fall Creek "Short Line" Railway Depot at the corner of North Tioga and Falls streets. *From the collection of the Tompkins County Historian, 31.4.*

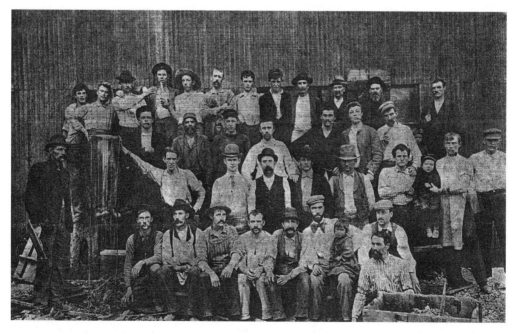

Photograph of workers, some with their children, at the Ithaca Glass Works. *From the collection of the Tompkins County Historian.*

creative talent and scenery. In 1913, a Russell Sage report observed, however, that Ithaca contained little manufacturing, and Cornell University was the city's major employer. The report found that seven hundred, or two-thirds of working men, were enrolled in unions, and while working conditions were "average to good," wages were generally $503 a year (or $9.67 a week), considered "very low and need[ed] to be supplemented." Ithaca's tax rates were thought to be high, while Ithaca "spent money liberally on her school system, more liberally than many cities of her size." In 1913, the Associated Charities supported one hundred people, or approximately 14.8 percent of the population, at a cost of more than $10,000 a year.

These findings from 1913 have held surprisingly true. The 2000 census (which lists information gathered in 1999) found that 40.2 percent of Ithaca's population was living below the poverty level; the average household income in 2000 was $21,441. There are people in need, even in a well-off and well-educated community. Taxation is high, wages are low and considerable money is spent on education. Two studies conducted in 2008 confirm this early judgment. In February 2008, there was a report noting that Ithaca suffers from a shortage of basic-skill workers, and *Kipplinger's* named Ithaca the third most "intelligent city in the United States" because "roughly half the population holds a bachelor's degree or higher." Yet, "18.5% of this high-skill workforce was underemployed due to the lack of high-skill, high-paying jobs." Ithaca's not-for-profit sector expanded in the 1970s, but many in it are not fully employed and often lack benefits, while those with full employment reflect the 1913 comment that low wages are the norm. Basic-skill workers—those very people who worked in Ithaca's factories at the turn of the twentieth century—are needed today for service-related or food-preparation jobs, healthcare support and personal care positions. Today, they make up only a quarter of the local workforce.

In addition, in 2000, the median home value in the county was $24,000 to $34,000, higher than in surrounding counties, the cost driven up by a shortage of homes in all price ranges and the ease of turning single-family property into rental units. Housing costs boost the cost of living in Ithaca. Local taxation, as pointed out in 1913, continues to be high.

These four basic observations about Ithaca in 1913 hold true: there are people in need, taxation remains high, wages remain low and considerable money is spent on education.

NATIONAL EVENTS COME HOME

National events occur like a series of echoes throughout the twentieth century. The Great War brought international issues home, and the city reacted, first with enthusiasm, then soberly, as it had during the Civil War, when the costs became known. Men marched in the streets, students drilled on campus. Approximately six hundred men from Ithaca participated in military service, and a number of women volunteered with medical units or with the YMCA. At the end of war, Ithaca celebrated. But there was a sour side to victory. Veterans returned to find their former jobs gone, and many local factories closed. Employment opportunities for most women were limited.

"Informal Armistice Day Parade," 1918, at the corner of State and Tioga streets. *From the collection of the Tompkins County Historian*, 37.2.

The "Legion Band," taken on the steps of the "old Tompkins County Nat'l Bank," East State Street, 1919. *From the collection of the Tompkins County Historian*, 4.10.

The economic problems that emerged following the First World War were caused in part by the cancellation of wartime contracts. Even amid the prosperity of the 1920s, a number of banks failed—although none locally—but, over the years, the value of farmland fell, technological advances replaced hand labor and company mergers resulted in a loss of employment. By Black Friday, October 24, 1929, the national annual per capita income was $750; the average farm income was $273; and farm prices fell. By 1933, thirteen million Americans had lost their jobs. Cornell steadied the local economy, but in 1933 faculty in the endowed colleges took a 10 percent salary reduction. In the state colleges, the figure was 6 percent, yet no one lost employment.

In 1920, the Ithaca Gun Company had produced fifty-two thousand guns; soon after, that number fell off. Morse Industries, a multipurpose company of factories, was purchased by Borg Warner in 1929. In 1930, the Peters Morse Corporation acquired the Allen-Wales Adding Machine factory, a part of Morse Industries, and the Thomas-Morse Aircraft Division moved from Ithaca to Buffalo.

The great economic downturn on Black Friday dampened the expectations of those invested in the stock market, but most Ithacans remember that they had not been living lavishly to begin with. As the economic doldrums settled in, they coped with less. Nonetheless, what happened in New York City and in stock exchanges around the world had a local impact.

In 1933, Franklin Roosevelt's first proclamation as president was to declare a bank holiday to begin the day after his inauguration on March 4. Our local banks closed. One Cornell student wrote home to report that she had cashed "Daddy's check at the co-op about two days before." As the economy worsened, Cornell's enrollment dipped, loan funds at the university were tapped out and greater numbers of students needed to work to remain in school. More than "five hundred students could find no work to do." Morris

At the Inlet Airplane Plant, the 135 H.P. Thomas Engine. *From the collection of the Tompkins County Historian, 3.24.*

Bishop, in his *History of Cornell*, wrote that one student became a "professional dancer, nay rather a gigolo. Others worked as meat-cutters, plumbers, painters, decorators. One was a tailor, one did embroidery, one gave religious talks." Four became a musical quartet; two "lived in a tent by Six Mile Creek." The Cornell Public Library closed from July 1932 until January of the next year. Building plans throughout the city stalled, and the Tompkins County Trust Company forgave business loans so that Ithaca College would not close.

Working conditions in Ithaca were difficult. Some made do; others, who needed work, turned to government-aid programs that were developed after 1935; and still others turned to their labor unions. In the 1990s, Chris O'Connor, Freeville resident and local firefighter, conducted interviews with seven people who spent the Depression years in Ithaca. Ethel Boyce remembered all the jobs she cobbled together in order to eat, glad to have a job at Allen-Wales in 1940 that paid $0.40 an hour. John Shepardson remembered having "twenty cents to buy groceries" for his family. During the hardest years of the Depression, 1935–36, Shepardson worked for Dean of Ithaca driving a truck six days a week for $12.00, three "bucks extra for Sunday." He helped "dig the hole for the State Street Diner" for $0.50 and a meal. In 1940, he drove a truck for Merchant's Delivery and received $22.50 for a six-day week. When he started at Ithaca Gun in 1942, he earned $0.60 an hour. Virginia Poole recalled the "hardships of it." She was an LPN at the city hospital, making $18 for a forty-hour week. Ernest Baker said, "It was goddamn tough to get along. Hamburg was three pounds for a quarter, but it was harder to get that quarter than it is to earn five bucks today." Eugene Ross came to Ithaca in 1936; when he was laid off by Morse Chain, his wife went to work at the Ithaca Pocketbook Factory for $0.30 an hour. Dan O'Connor, Chris's father, recalled that society separated into the "haves and have-nots." These were all working people, seeking employment and at the mercy of the availability of work. They struggled to get along, changed jobs frequently and made do as best they could.

When asked how they judged the conditions in Ithaca, they all agreed that unemployment was less severe here than elsewhere due to the presence of Cornell, Ithaca Gun Company and Morse Chain. Yet, local wages were low: "They paid pitiful poor wages," said one. Work was also available for young men through the Civilian Conservation Corp (CCC) and the Works Progress Administration (WPA), called "We Putter Around" programs. There were "no breadlines in Ithaca," and those who were working took care of those who were not. Most people interviewed by O'Connor tried their best to stay off relief. But, "you can't be choosy in a depression," observed Mrs. Poole. Each of the people O'Connor interviewed was or became a union member, and each one believed that working conditions improved because of the unions.

The Depression experience of those who lived on a farm, or were related to farmers, was somewhat different from that of people looking for work. "Out in the country," commented one, "no one had any money before the Depression, but at least we could grow our own food and cut our own wood." Their stories are of hard times, but also of families listening to the radio, playing cards and games, of sharing shoes and of limited horizons. When there was a little money, they went to the movies.

To compound difficulties, in July 1935 there was another flood. There had been difficult storms that caused flooding in 1905 and 1922, and almost yearly there was water

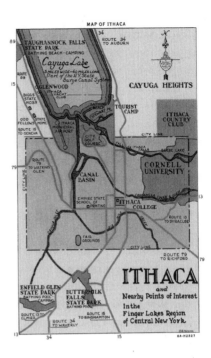

A postcard map. *Digital scan provided by Bill Hecht139/13930.*

in low-lying portions of the city. But in 1935, when the rains came, they pounded down at unprecedented levels. During one twelve-hour period, 5.48 inches of rain fell. The south end of the city appeared to be a continuation of Cayuga Lake, and Buttermilk Creek became an uncontrollable river. Cascadilla Creek overflowed, and yellow floodwaters covered North Cayuga, Tioga and Aurora streets. Five Mile Drive was the scene of several rescues; Floral Avenue was underwater. The police closed every main highway but one in and out of Ithaca.

Gladys Sperling remembered driving through a maze of roads in Dryden trying to find her way to Cornell in the midst of the storm. Culverts and bridges were out of commission. Water tore across Taughannock Boulevard, and there was considerable damage to newly paved Hector Street. Pavements were upended along University Avenue and Lake Street. Percy Field and the golf course were underwater. Renwick Heights was threatened. The Black Diamond train stalled on the tracks outside Ithaca.

Reacting to a warning blast from the fire siren, 651 refugees from downtown Ithaca camped in Cornell's Drill Hall, at the Moose and Eagles' lodges, and many families took their cars to the hilltops for safety. Farm animals drowned, and there was extensive crop damage. In the midst of all this, there was a fire on Meadow Street. The numbers changed day by day, but it was finally determined that flooding caused eleven deaths. Property loss was estimated at $5 million.

While the *Ithaca Journal* covered local scheduled events, news of the flood dominated. The CCC came to the aid of those in need, and the fire department pumped water from cellars and removed stagnant surface water from backyards. A relief committee sponsored a three-hour show at the State Theatre, a benefit for flood victims with "Professional Vodvil Acts." Ithacans were warned about believing and passing along

unfounded rumors, and the Red Cross swung into action. The common council set to work to devise plans for reconstruction.

In 1939, Europe went to war. In 1941, war came to the United States. Adelaide Rice said, "We knew war was coming." The suddenness of it and the "cruelty of the unexpected attack blasting into a peaceful December Sunday shocked and left us shaken." December 7, 1941, ended the long, tense era of the 1930s. The government called members of the armed forces back to their posts, and farmers went to work "around the clock." Rationing began. The selective service board registered young men, and some "farm girls," trained by the government, arrived to plow and tackle farm work. As the war progressed, the shortage of farm labor became so acute that prisoners from the war camp near Oswego, wearing gray uniforms with large "PWs" painted on the back, "came by the busload" to help with crops.

The *Ithaca Journal* observed that when the Great War had begun in 1914, people had cheered, and a local siren clanged seven long blasts. There had been flags and optimism. In 1941, having learned the costs of war on foreign soil, Ithacans were quiet and cautious, wary of the dire days to come.

Esther Johnson was a teen during World War II. She became a USO entertainer, going to Geneva once a month to help with parties and entertainment for soldiers from Romulus and sailors stationed at the Sampson Naval Base. The Ithaca group of "all Afro-Americans" was chaperoned by Mrs. Anna Johnson. Esther Johnson wrote that they "danced our feet off," to Melotones, Doc Small, George Reed, Harold Cook, Wally Thrill and others.

Ithaca experienced the war in many ways. The papers carried notices about men going into military service, of those wounded or killed, of prisoners in war camps or those who were missing. Ultimately, 4,470 men from Tompkins County participated directly in the war effort. There were also special civilian efforts. Homeowners stacked newspapers at the curb for collection, children collected tinfoil from chocolate and cigarettes and housewives preserved cooking fats. There were blood banks and war relief collections for the Finns and the British. There were efforts made on behalf of military families at home, and everyone endured rationing, underwent plane-spotting instruction and covered windows during blackouts. Paper shortages resulted in the *Journal* banning advertisements and shortening the length of each issue. At the same time, there were food, feed and fuel shortages—and hoarding. There was a butter shortage, and in 1946 milk went up by twenty-one cents a quart. There was even a shortage of beer because grain was needed for bread. The Ithaca Famine Emergency Committee monitored the use of fats and grains, causing local restaurants to close one day a week.

When Germany surrendered, local citizens received the news quietly, but when war in Asia ended twenty-five thousand people swarmed into the streets to sing and dance. Death notices from battlefields disappeared, while the newspaper recorded the loss of men once believed to be prisoners of war or missing in action, along with those who survived. On the heels of celebration that fall, the government cancelled war contracts. The Ithaca Gun Company let 350 workers go, and two months later, another 500 local workers lost their jobs. Union activity increased and brought about some rise in local wages; at Ithaca Gun, the hourly rate went up by $0.10. Morse Chain workers received $0.09 more an hour for a forty-hour week. Local plumbers struck in 1946 and were rewarded with an hourly wage of $1.75.

The Past that Was Yesterday

I thaca developed its particular character over time, responding to historical forces and to conditions that were primarily local. Ithaca's noteworthy traits include the increasing diversity of the population and an economy that lost most of its industrial base and became heavily dependent upon its educational institutions. There is also the zeal Ithacans take in organizing for social need and cultural richness, and for environmental protection. The local is also shaped by state and federal funds that often dictate what is possible.

The two major themes that help define Ithaca have their origins in the late nineteenth century. One is the city's growing and diverse population; the other is the zeal with which Ithacans organize. Each deserves some attention.

The development of Ithaca's population is distinctive in the region. Over the nineteenth century, Ithaca's population increased, even while there was slow growth and decline throughout the rest of Tompkins County. In 1890, Ithaca had 11,079 residents, or one-third of the county's total population of 32,923. By 1910, the county's population had grown by approximately 700 persons, while at the same time the city's population increased by 3,728, reflecting a considerable loss (of 3,028 persons) of rural population as the city grew. Ithaca experienced its largest population increase, growing by 9,527 persons, between 1940 and 1950, reflecting a readjustment that followed the end of the Second World War and also the conscious decision on the part of Cornell and Ithaca College to increase their programs and expand their student bodies. Cornell added two hundred new faculty positions. In addition, between 1945 and 1948, 77 percent of all male students at Cornell enrolled on the GI Bill. Ithaca's total population in 1950 was 29,257.

POPULATION OF ITHACA, VILLAGE/CITY

1940	19,730	1980	28,732
1950	29,257	1990	29,541
1960	28,799	2000	29,287
1970	26,226		

These newcomers faced a severe housing shortage. There had been relatively little new building during the war. Cornell attempted to address the problem with government surplus buildings that it installed on South Hill for faculty and by creating Vetsburg, a cluster of homes for veterans and their families, on East Hill. Classes met in Quonset huts, but a new dormitory for male students burned down before it was occupied. Local public school enrollment also increased by approximately 18 percent—many of the students were the newly enrolled children of veterans.

Ithaca did not enjoy steady growth. There was a slight decline in the city's population after 1970, as evident in the figure for 1980, due to a continued loss of local industry and because a number of residents left Ithaca's older housing stock for newer homes in the county and elsewhere, following a national trend. In addition, some city residents departed to remove themselves from neighborhoods where more and more private houses were being converted into apartments that were rented to students. In 2000, the federal census reported that of the 10,287 housing units in the city, only 26 percent were owner occupied, while 74 percent were lived in by renters. Rental units, especially those with absentee landlords, often lack attentive building maintenance, observes Nancy Schuler, a current member of Ithaca's common council who walks her East Hill neighborhood daily. This situation has become especially acute on East Hill, where one common council member over the past ten years has been drawn from the resident-student, rather than the resident-homeowner, population. There has been a marked transformation of Collegetown, and efforts to provide services and engage in planning for growth are ongoing.

THE MANY FACES OF ITHACA

The diversity of Ithaca's population presents additional patterns that also begin in the late nineteenth century. Until 1880, most Ithacans were native-born Protestant Americans, mostly white, with a small black contingent. There were also some residents born elsewhere—Canadians, a number of people from England and Germany and a significant and growing contingent of Roman Catholic Irish. After 1880, the United States admitted greater numbers of immigrants from countries outside Western Europe, and Ithaca's ethnic mixture became diversified. Over the twentieth century, Ithaca's population further broadened, creating a new and interesting rainbow of people from varied backgrounds and races.

In 1920, foreign-born residents, as evidenced in the federal census, illustrated some of the early changes taking place. That year, there were 282 people who had been born in Ireland, 275 in Italy, 194 in England, 180 in Hungary and 152 in Canada. The number of Irish, lower than the mid-nineteenth-century figure of 1,177, is somewhat deceptive, however, because the 1920 number only counts those who were immigrants, not those of Irish descent, the second, third, and fourth generations who were born in the United States and were living in Ithaca. Had the question asked how many people claimed to be Irish, the number in 1920 would have been much greater. The 1920 census listed one person in Ithaca identified as "Indian, Chinese, and Japanese," not

specifying which ethnicity that lone Asian was. The number of Asians was probably somewhat greater than one, but the census did not always capture resident students in its count.

Over the next thirty years, there have been some interesting changes. By 1950, the number of people in Ithaca who had been born in Italy was 346, larger than any other ethnic group in the city. There were 69 Greeks in Ithaca in 1950 (there had been 33 in 1920 and 53 in 1940), a small but growing population that created St. Catherine's Greek Orthodox Church in the 1950s. The congregation met on Bryant Avenue for worship before buying the former Congregational church on West Seneca Street. The number of people born in Ireland declined over this same period to 104, although Ithaca had several mayors of Irish descent between 1945 and 1975. The total number of foreign born in 1950 was 1,957, including Canadians, English, Germans, Poles, Czechs, Hungarians, 20 Mexicans, 61 from the rest of the Americas and 102 Asians.

Robert Garcia, who grew up on Cascadilla Street in the 1930s, reminisced that his family was the only one in the neighborhood that spoke Spanish, and they lived close to Italians, Hungarians, Jews and African Americans, a population mixture that he took for granted. Their differences were seen in the produce in backyard gardens and from the aromas emanating from the neighborhood kitchens. David Potori, writing in the *Journal* in 2008, recalled that his neighborhood around Washington Park was populated by Czechs, Poles, Hungarians and Italians. "You could walk in any direction," he said, "and know who lived in each house, where they worked, and their children's names. There were godmothers and godfathers, grandmothers and grandfathers, cousins and second cousins." The neighborhood was a known and familiar place.

The number of Jewish residents in Ithaca also increased. The earliest firm number I have found comes from an 1896 religious census in which seventy-four Jews were listed. In 1906, Jews founded a congregation, Chevra Kadisha, at the home of a member, echoing the founding patterns of other religious groups that began by meeting in private homes before erecting a house of worship. Reflecting an earlier time when the community joined together to build the Presbyterian church, people of many denominational preferences, including local Christian clergy, some community leaders and students, contributed to the building of Temple Beth-El. By 1929, there were sixty Jewish families and about six hundred Jewish students at Cornell and Ithaca College. In 1942, Hillel, which had been based at the temple, moved to campus, and the temple congregation hired its own rabbi, who helped align the local synagogue within the conservative branch of Judaism.

Diversity has not always been regarded by everyone positively. Americans have from time to time reverted to nativism—an anti-foreign, anti-immigrant stance. In Ithaca in the nineteenth century, there was some enthusiasm for the Know-Nothing Party, which objected to the presence of foreign born individuals, especially the Roman Catholic Irish. In the 1880s, there was an Ithaca chapter of the Order of the American Union—another anti-foreign group. Reflecting anxiety during the 1920s, with its even greater demographic diversity, was a growing intensity of anticommunism,

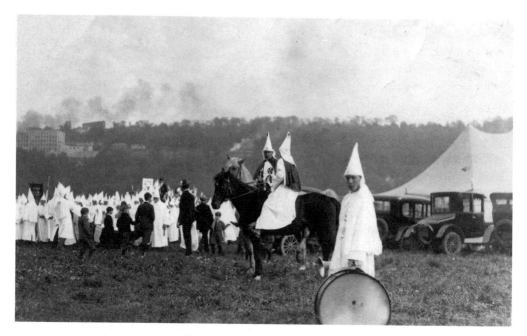

A Ku Klux Klan gathering at the Ithaca Fairgrounds, along Route 13, October 3, 1925. *Photo taken by George Kirk, given to the author by Hazel Mandeville.*

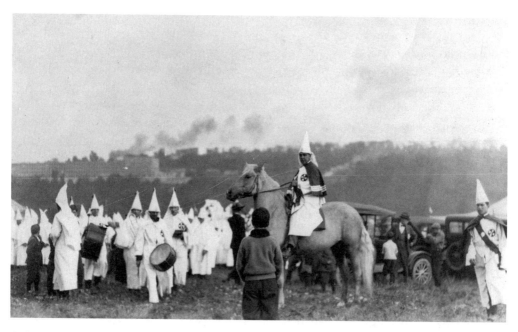

A photo by George Kirk of a 1925 Klan rally, with South Hill in the background. *Donated by Hazel Mandeville, whose father had sold the horse to "a Mr. Marion," in collection of the author.*

racism and increasing anti-Semitism that in some places resulted in quotas for Jewish students at colleges—although not at Cornell. Anti-foreign sentiment was another component of that decade, which saw passage of the Immigration Act of 1924, restricting by ethnicity the number of immigrants admitted to the United States.

The Ku Klux Klan objected to blacks, Roman Catholics and foreigners. In its first appearance in the 1870s, the Klan was racist, but in the 1920s it broadened its targets. The Klan was briefly popular in a number of Northern states, and there were Klan members in Ithaca, and throughout the county, though their numbers were probably small locally. The 1920s Ku Klux Klan sought the "preservation of America, the protection of the home and American womanhood." Their targets were African Americans, although they represented only 4 percent of the local population, and Roman Catholics because of their "allegiance to a supernational Pope." They also targeted Jews. The Klan advocated a "militant Americanism" based on its members' "racial superiority." The Klan had secret passwords, much like the Masons before them, and a complete alphabet to confuse outsiders. What it offered members was a sense of belonging amid a changing population.

The peak years of Klan activity in Ithaca were 1923 to 1925, but there was some Klan sentiment well into the 1930s. In 1967, a man who lived on Linn Street told me that he still had his Klan outfit in an upstairs closet and was ready to put it on. Klan members burned a "fiery cross" on West Hill in 1923, and again in 1924. That year, they also lit a cross on Cornell's library slope, which students extinguished. In March, there were four crosses on hills surrounding Ithaca—probably as startling as Professor Anthony's outdoor arc lighting had been—and others in Lansing, where some residents were threatened by Klan antics. At a funeral held at the Lake View Cemetery in 1924, twenty-five Klan members, dressed in their white regalia, appeared unexpectedly from behind a clump of trees to pay respects to the deceased. Local advertising even proclaimed Klan allegiance and featured Klan messages: "Kornell Kleaning Kompany" promised suits pressed and laundry folded. "Kellogg Keeps Kerosene," announced C.M. Kellogg. A gas station announced that it offered, "100 Per Cent American Low Prices," along with "Klean, Kareful, Kourteous Service." Reports of local Klan activity were carried in *The Vigilance*, a Syracuse newsletter, and a Klan parade in Binghamton attracted many thousands, and the *Washington Post* reported that two Tompkins County residents in their Klan outfits married at a Klan rally on the Mall. As late as 1930, Rym Berry—a wise and wonderful writer of an *Ithaca Journal* column entitled "State and Tioga"—railed against the Klan and against "red baiting." He wondered in print what housewives thought of finding their sheets punctured with eyeholes? Could they be hung to dry on outside clotheslines without incensing the neighbors? Berry also suggested that the way to counter such hateful groups was simply to take the starch out of their costumes by laughing at them.

A RAINBOW CITY

As Ithaca's population increased over the course of the twentieth century, so did its diversity. In 2000, there were 1,965 African Americans in Ithaca, making up 6.7 percent of the population. Among the newcomers, there were some interesting shifts. In 2000, there were 4,650 foreign-born residents in Ithaca, or 16 percent of the population. Of those, there were 3,998 people identified as Asians (or 13.7 percent of the total population), and 1,555 Hispanic or Latinos (5.3 percent of the city's population). In the nineteenth century, there had been only a few Spanish-speaking people in Ithaca, and the number of Asians from any national background was always small. For example, in 1900 there had been but two Chinese, listed as Buddhist men who ran a laundry; there was one in the 1910 census. As late as 1988, Jason Wong remembered that when he came to Ithaca in 1974 there was a "strange lack of Orientals." Then he discovered the Asiatic Gardens and the "embracing friendship of its proprietor, Suzie," who had become something of an institution in Ithaca. Over the fourteen years Wong lived in Ithaca, he witnessed a "large influx of Orientals," which led to many new Chinese restaurants, and suddenly "Dim Sum, that gourmet brunch, was available at several establishments."

These shifts in population are an important characteristic of the city, something celebrated today with associations of Latino residents, and an Asian American Association that promotes yearly dragon boat races on the inlet. Ithaca reflects the changing ethnicities of people who have immigrated to the United States during the twentieth

The Namgyl Monestary, established in 1992 at 412 North Aurora Street. *2008 photograph by author.*

century and the fact that the country's immigration policies had finally loosened to admit somewhat more freely people other than those who were European born. In addition to Vietnamese, Russians, Koreans and other newer immigrants, in 1992 Tibetans established the Namgyal Monastery on North Aurora Street as the North American Seat of His Holiness, the fourteenth Dalai Lama. The congregation is currently building Dü Khor Choe Ling, a monastery and education center on Tibet Drive, off Route 96, just south of Ithaca College.

GETTING ORGANIZED

Ithaca exhibits a phenomenal zeal for organization that can be dated to last third of the nineteenth century. At that time, men in Ithaca created a wide variety of fraternal lodges, tribes, chapters and clubs. These provided members with a sense of belonging, a group in which membership entailed committees and rank, leadership training, a community of like-minded people and a national affiliation, rather like the Greek-letter fraternities on campus. Women were generally members of church, missionary or mite societies until 1870, when a small gathering of prominent women, representing various churches, met and formed the Ladies Union Benevolent Society (LUBS). Their initial concern was to aid "homeless women unable to care for themselves" in a building called the Home on South Aurora Street. Here, women with small means and no relatives could live out their days with as "little feeling of institutional living" as possible and a "maximum sense of dignity," their lives overseen by a matron and LUBS. The home was transformed into McGraw House, still with LUBS oversight.

In 1886, LUBS turned to the problem of children who needed care, and it opened the Ithaca Children's Home on West Buffalo Street. This was not an orphanage, but a place to which working mothers, with certificates from their employers, could bring children at a cost of five cents a day. Soon, others turned to the Children's Home: the poor master brought Willie Doe in 1886 and agreed to pay one dollar a week for his care; a father brought his two motherless children; and children who were judged to be "at risk" were also admitted. In 1888, the board of matrons had to consider the extent of its authority as it began to place children for adoption in appropriate homes. The Ithaca Children's Home functioned until 1951.

The director of the Children's Home, appointed by LUBS, was Mrs. Elizabeth Beebe, a consequential woman who planted the idea of benevolence in the community beyond traditional bounty to family, neighbors and church members. Elizabeth Beebe was divorced in an era when divorce was not socially acceptable but, in her case, lacking responsibility for husband and household made her the logical candidate to take over the duties of city missionary when the man who had tried to bring religion and relief to people living along the inlet proved to be ineffectual because of mistrust by those he was attempting to aid.

In 1883, one hundred of Ithaca's community-minded men formed the Society for the Prevention of Crime (SPC) and hired an agent to patrol the streets, to right wrongs, save the poor and weak and bring bullies to justice. The SPC functioned, as other national

Windows at the former Ithaca Children's Home at 518 West Seneca Street. *2008 photograph by author.*

organizations did at the time, on behalf of social control, acting, as the Moral Society had earlier, where no laws existed. Both groups formed for the same reason: each sought to ensure that "unseemliness" did not sully Ithaca's reputation and to control what it considered to be undesirable elements and behavior. The SPC agent spent most of his time around the inlet, in Ward I. He also patrolled Aurora Street to alert young women of the dangers of passing the bars, and he sent two women off to the Hudson Reformatory when they persisted in what he thought was provocative behavior. He fined people for mistreating horses (the SPCA comes out of this movement), reprimanded children playing hooky from school and forced husbands to support their families. The SPC was patronizing. It acted in what it believed to be in the community's best interests, working for public order and safety, but finally, in 1902, the directors "abandoned their work" as other organizations and the police took on social problems, along with criminal behavior. Later, governmental services would aid those in need.

Benevolence is something Ithaca learned, stemming from the growing divide between those with education and employment and those people living on the margins. Medical care moved from private homes, and in some cases doctors' offices for those who could afford it, to a city hospital that opened in 1888 in the Burt Mansion on North Aurora Street near Cascadilla Creek. The hospital expanded into an annex and, in 1911, inaugurated its then-modern facility on Quarry Street, flanked by an addition of a nurses' home and an isolation ward, considered a "monumental community achievement." Also in 1911,

the Ithaca Tuberculosis Association organized, opening the Cayuga Peventorium in 1915 for thirty children. Within a few years, it became the Tompkins County Tuberculosis Hospital. In 1956, Tompkins County assumed responsibility for the hospital, later building the Cayuga Medical Center on the adjacent lot overlooking Cayuga Lake.

Our relationship to the idea of philanthropy has changed over the course of the twentieth century. As community needs became more apparent, Ithaca developed a strong sense of charity—philanthropy or welfare—as an acknowledgment of social responsibility to the larger population, and it organized to meet those needs. A number of organizations formed: the Children's Home, the Old Ladies' Home and the Inlet Mission, all influenced by Elizabeth Beebe.

The Associated Charities was established in 1891 to supplement and broaden Beebe's work at the Inlet Mission. That group evolved into the Charitable Organization Society in 1893, which lasted until 1899. The Salvation Army established a post in Ithaca in 1892 to extend aid to the poor and manage relief efforts. In 1906, the Social Service League was created, erecting the West Side House in 1916 and the North Side House in 1927. Growing out of the Social Service League was a new group called the New Associated Charities, formed in 1912 with the aim of coordinating charitable activities. Its efforts failed, however, possibly because of the need to mediate between the various jurisdictions claimed by individual charities, but also because of World War I, which prompted a bevy of new groups to form to provide relief and aid to military families and those abroad. The need for coordination of these war efforts led, in 1917, to the creation of the Tompkins County War Chest.

By 1921, seeking coordination and greater efficiency, and having learned from the positive experience with the War Chest, community leaders founded the Community Chest. This was an umbrella organization of at least fifteen groups, including the Boy Scouts (established in Ithaca in 1914) and Girl Scouts (1919), that led to reduced costs for all and successfully augmented agency operating budgets. The Community Chest became the Tompkins County Community Fund in 1956. In 1973, it was renamed the United Way of Tompkins County. Over time, the social services professionalized, and many came under state regulation. In the interstices, where the state did not function, Ithaca provided its own unique solutions.

The threat of poliomyelitis prompted a local organizational response, especially from Mary Hibbard, who founded the Home for Infantile Paralysis in 1921, an epidemic year. Between 1945 and 1949, there were twenty thousand cases across the nation during each of those years. In Ithaca in 1945, fourteen young people were stricken in the city and over twenty countywide. Beverly Baker, who grew up on South Geneva Street, commented that an interesting consequence of the polio years could be seen in the declining use of Stewart Park. Families, wanting to protect their children from crowds, ceased gathering and cooking dinner at the park and instead invested in backyard barbecues. In 1952, another peak year, there were fifty-eight thousand cases of polio in the United States. In 1955, with the development of the Salk vaccine, children were inoculated, and the number of cases, locally and nationally, declined. Today, the Home for Infantile Paralysis, known for some time as the Reconstruction Home, is now called Beechtree, a skilled nursing facility and rehabilitation center.

Among the city's many responses to initiatives from the state was the creation of the Ithaca Youth Bureau (IYB), which began operations in 1948. New York offered financial aid to communities for the development of youth programs; the state's interest was the prevention of delinquency. Ithaca's goal was to provide wholesome activities for young people. First located in the Central Fire Station, the IYB moved into the old naval reserve building called the "Tin Can." It is now in its own building near the entrance to Stewart Park.

A VAST ARRAY

Cultural enrichment in Ithaca expanded in the postwar years in an effort to offer what some newcomers missed about life in larger urban centers, in part to provide an opportunity for local artists, and in part to provide cultural education, especially for the young. There are close to one hundred different arts organizations in Ithaca, from ballet and dramatic companies to a community orchestra and bands, a community chorus, specialized singers, mimes, storytellers, an early music society, the Community School for Music and Arts, galleries and studios. Many of these provide points of intersection for Ithaca's diverse population. The Hangar Theatre began in the 1960s as the Center for the Arts, with its goal to bring theatre to summertime Ithaca in the old airport hangar, which was left empty when the aviation facilities moved from their location along Taughannock Boulevard to a county-run airport on Warren Road. Year-round theatre has been provided by the Firehouse and First Street Theatres, pleasing smaller audiences with new and sometimes startling plays, and, since 1991, at the Kitchen Theatre in the Clinton House, where something "is always cooking."

The astonishing Sciencenter began as a volunteer science program in the schools. The program grew, took over an old city waterworks and then, with community participation, erected its innovative building in the 1980s. Since then, it has expanded several times to meet the needs of visitors, who flock to see its ever-innovative exhibits and displays. The Sciencenter is part of the Discovery Trail, enticing residents and tourists to sample a variety of arts, science and culture.

Harmony, of course, is not always achieved, or even desired. A variety of opinions can always be found, and Ithaca's size and distance from places of greater size do not mean that the city is spared the storms of the day. Indeed, a segment of Ithaca's population always seems agitated and deeply committed to expanding social justice, protesting for political action or voicing environmental concerns. The battle for civil rights and for greater inclusion of all peoples into the political forum has been an important part of the recent local discourse. Martin Luther King Jr. came to speak twice in Ithaca, in 1960 and 1961. Assessing that era, Louis Cunningham, the African American director of the Southside House who is involved with both the black and white communities, said, "Ithaca didn't have major problems [during the rights era.] There were a few protests, but most issues were resolved through negotiation." At Cornell, the spring of 1969 proved to be electrifying, and the story is told well in Donald Downs's book *Cornell '69* (Ithaca, 1999). The outcomes led to a recognition of the needs of black students at

Cornell and the development of better-quality housing for poor people "of all races," Cunningham said, built by the Ithaca Housing Authority. In this, Ithaca's size worked to its advantage because people knew one another and were willing to discuss issues candidly. Cunningham, a significant community leader while in Ithaca, was quoted in the *Ithaca Journal* observing that, when there were difficulties, or when a young person was in trouble, "I would be at the forefront of the attack, making sure that…we were not treated as second-class citizens."

There is always the sour and sweet. Ithacans organize to create a fairer society, to consider national problems and to explore ideas, options and assumptions about life that had long been taken for granted. All the while, local problems roiled Ithacans. Over the past forty years, Ithacans have divided over what books should be found on the shelves of the school libraries, over alternative schools, the new math and experimental curriculums. For years, Ithacans debated the merits of bridging the inlet, how a better flow of traffic could be achieved, the creation of Route 13 and, more recently, the expansion of national discount stores into the city, which everyone now accepts and, in some sense, appreciates. These community discussions—often representing significant divisions in thinking—are an example of Ithaca's particular way of going about things. It has always been "*so* Ithaca" to sit on a committee, debate process, pass petitions, dissect solutions and write letters to the editor. Students and community members have protested the possible use of nuclear weapons, while Freedom Buses left to promote voter registration in the South. There were multiple efforts to improve the quality of life, and organizations addressing social problems proliferated.

MODERNIZING THE CITY

In 1954, the city faced the need to update its public services and proposed a plan of annexation with the Village of Cayuga Heights. A larger population base would allow the city to qualify for a more advantageous level of state and federal grants and increase the tax base to help pay for improved services, such as sewer and fire protection, which the city was already providing to residents of the village. In addition, many of the people living in the village worked in the city, and residents of Cayuga Heights were involved with city organizations. Village residents already exerted influence in city concerns. There were many good reasons to consider amalgamation.

The village of Cayuga Heights formed originally in 1911, when thirteen residents living within the Town of Ithaca met to discuss their shared concerns about the condition of the roads, which were unpaved, about snow removal from the sidewalks and about tent caterpillars proliferating in neighborhood trees. The idea of creating a village was raised in 1915, when the population was 137. By 1950, the village had grown to 2,000, and it expanded its borders in 1954 to incorporate homeowners who lived within the Cayuga Heights Water District.

Village trustees considered the costs of political union with the city, for it seemed certain "that if the village continues as a separate entity, the cost of living in the village is scheduled for substantial increases." Trustees stated they were "in favor of annexation

upon the terms now proposed." The vote showed an eighty-point spread, in which "the perils of the status quo [were thought] to be less than the perils of annexation," and, somewhat to everyone's surprise, the issue was dead. The city broached union with Renwick Heights, which did not happen; nor did union between the Town of Ithaca and the city, although they were already "geographically, sociologically and economically joined." There are discussions today about town and city cooperation where there is duplication or where savings for both governments can be made. Consolidation is most unlikely, even though it would be an efficient and logical step to take.

DOWNTOWN SHIFTS

Mid-century, the trains stopped coming to Ithaca. Ruth Reed Bailor told me of growing up on Water Street in the 1920s and listening to the grinding wheels of the train as it eased along the tracks heading down South Hill. The last passenger train, the Black Diamond, rolled out of Ithaca in 1959. The final freight train departed in 1961. That was one shift, made in preference to transportation by car and plane, that offers an example of the sour and the sweet: we miss the trains today. We have not supported public transportation, which, today, with high gasoline prices and an awareness of the environmental impact of the automobile, would be most welcome. Today, only the salt and coal trains make their way through Ithaca to the salt factory farther up the lake.

Another shift concerned the everyday population of Ithaca's core—its downtown. In 1957, Ithaca College opened its new campus on South Hill, proof that the conservatory nurtured here had become a significant national institution requiring better facilities to match its larger purpose. It had expanded beyond Boardman House, and it had outgrown holding gym classes in the former Star Theatre. Ithaca College needed modern theatres and radio and television studios for its pioneering media studies. College students had performed in DeWitt Park and marched though it to commencement. Ithaca College students were an important component of the downtown community, moving in and out of shops and restaurants and living in local homes. They were a familiar presence, and then they were gone from downtown as an everyday presence, excepting for weekend forays to bars and restaurants. Another shift in the population occurred in 1960, when the board of education opened Ithaca High School's new building on what was once Percy Field. After a 1978 fire, the YMCA moved to modern facilities in Lansing. The relationship between Ithaca and its young people changed rather dramatically.

In 1960, most people in Ithaca would not have considered Ithaca an "inner city," a term used for the declining centers of America's large urban centers. Passage of the Housing Act of 1949, however, provided federal aid for redevelopment and offered the opportunity to update the city, which faced a set of problems that had not yet been addressed. Ithaca was admittedly "dowdy," containing a number of older buildings that needed rehabilitation.

Most of downtown's ills stemmed from the automobile. Ithaca had made the transition from being a nineteenth-century walking village to a city expanded by trolley and bus transportation, allowing people to live farther from their work and central places. After

the turn of the twentieth century, however, Ithaca became a city of the automobile, with its very particular needs. Americans are said to love cars, but automobiles need service stations and, above all, parking. In addition, by 1960 residents were conscious of a "lack of modernity" downtown and the fact that there was under utilization of space and growing competition from shopping centers located just at or beyond Ithaca's borders. The Ithaca Shopping Mall and Jamesway (now Triphammer Mall) were the earliest.

As downtown's problems became more acute, the common council applied for a federal grant to consider Ithaca's central one hundred acres. Focused on the hotel block (where Center Ithaca is located today), the plan that finally emerged promised increased parking and improved traffic and pedestrian circulation, with the hope that new businesses would be attracted downtown. In 1964, the common council approved phase one of the Center Ithaca Renewal Project, with priority given to parking and landscaping. It was at this point that I arrived in Ithaca. In August 1965, I drove downtown for the first time, parked on Seneca Street near Tioga and looked appreciatively at what was then city hall, a Greek Revival–style building erected as the village hall in 1843. I went to the Ithaca Savings Bank (now gone), to Holley's (now gone) and to Penney's (also gone).

This was built as the village hall in 1843 and served as city hall until 1965. *Photograph from the collection of the Tompkins County Historian, 30.8.*

The next week, when I parked at about the same spot, city hall had disappeared, leaving a gap like a missing tooth. That lot became the site of a parking lot and, later, the Seneca Street parking garage. Urban renewal of downtown came with the expectation of that a new city hall would be built, but instead, the city acquired the New York State Energy and Gas building at the corner of Green and South Cayuga streets, where it has remained ever since.

In reaction to the demolition of the Cornell Library at the corner of Seneca and Tioga streets in 1960 (now a bank parking lot), the removal in 1965 of the old city hall, and threats to other significant downtown structures (the Boardman House on East Buffalo Street, the Clinton House and, in 1974, the DeWitt Park Baptist Church) in 1966, concerned citizens created Historic Ithaca to raise public awareness of the value of diversity of the downtown-built environment and to promote new uses for older buildings. In 1970, the common council created the Ithaca Landmarks Preservation Commission to support private preservation activities and to monitor the city's built environment. In 1979, Ithaca designated DeWitt Park as a Historic District.

While some buildings were saved, the plan for the center of Ithaca moved along, though not exactly according to plan. A downtown anchor store was never secure, and the land next to the old Rothschild's Department store was called a "grave yard of developer's dreams." In 1974, Walter Wiggins built the Ramada Inn on South Cayuga Street, now the Holiday Inn, a multistory building that towers over the rest of the city, at first thought to be out of scale, but now considered part of the local landscape. The original timetable of five years for renewal proved to be unrealistic, and not all features of the planning document were addressed. Considering the era and what happened elsewhere, however, the effects of urban renewal in Ithaca were generally benign. There was no whole-scale destruction of entire blocks of buildings and, as Stuart Stein said recently, we might regret some of the decisions made in the 1960s, but the emphasis was on beautification, on access to the downtown center for people arriving in automobiles and to encourage growth.

A further shift came in 1974, when Mayor Edward Conley dedicated the Ithaca Commons, the first pedestrian mall in the state, achieved by closing off East State Street from Cayuga to Aurora streets and Tioga to Seneca. The Commons was built with local funds totaling almost $1 million. Its purpose was to revitalize downtown by creating community space and an attractive place to shop. While the Commons has received mixed reviews over the years from merchants, it must be credited with providing space for a variety of events and for reviving, or even creating, a venue for downtown festivals, which have replaced the parades that once flowed along State Street. The Commons provides Ithaca with an urban space where people meet, dine, shop and enjoy concerts and other performances.

A monument in front of the 1862 county clerk's office, now the Tompkins Trust Company building, reproduces several lines from Cavafy's poem "Ithaca": "Ithaca has given you the beautiful voyage. Without her you would have never set out on the road." For an informed tour of the Commons, see Daniel R. Snodderly's book, *Ithaca and Its Past* (Ithaca, 1982). The text provides information about the buildings that surround the Commons, and it documents the ongoing transformation of this important public

space. The city is currently planning a review of the Commons to assess how it meets current needs, which include the same things that were of concern when it was created: a vital shopping and dining area, a public forum with convenient parking and space for community gatherings of all sorts. Recognizing its vital role in the community, Cornell University moved its large development operations to the Hilton Garden Inn located at the corner of Seneca and Tioga streets, just about where I experienced my introduction to Ithaca in 1965. Beginning in 1995, the university also began providing funds to the city for transportation, parking and housing, all of which testify to the interdependence of town and gown.

FESTIVALS

The Ithaca Festival, that joyous mixture of people, music, food, dance and celebration, began in 1967, before there was a Commons. When Commons space became available, the festival filled it with people, presentations, crafts and food. Over the years, the festival has featured playground activities and face painting for children, mimes, vendors, historical dramas, an exuberant opening parade with Volvos in tutus and chain saw marchers, unicyclists and musicians. It has also had to cope with Ithaca's capricious weather, so that festival garb each year is rarely without umbrellas. Perhaps the parade will soon include Priuses in ponchos—appropriate environmental *and* weather statements! And *so* Ithaca.

The theme of the 2008 festival was "We Are Ithaca," and its parade was declared "far and away the best thing to ever happen to *civitas* this side of community gardens." Ninety-two groups, and more than sixteen hundred participants, marched along North Cayuga Street—in the rain—cheered by crowds (with umbrellas) massed along the way. The Sunday spectacular was entitled "Stand Up for World Peace." While applauded by thousands who created a gigantic human peace sign at Stewart Park, it was, this being Ithaca, derided for introducing a political statement into a cultural and festive event. The festival, however, has always been political in that it arose from a spirit of community activism in the 1960s, and it has given voice and a stage to many causes in the name of a community happening. To be at the festival is to be part of the Ithaca community.

The success of the Ithaca Festival did not go unnoticed, and since its inception Ithaca has become the site of many public celebrations. Almost every fall weekend, and many in the spring and summer, feature a special festivity on the Commons: a chili cook-off, an Apple Festival, a Latino Festival, sidewalk sale days. Even the highly popular Farmers' Market at Steamboat Landing is called a "Festival on the Waterfront."

The Commons has become the place to circulate petitions, as Owego Street was in the 1840s, when the great issue was abolition. It is where Ithacans protest for world peace, disarmament, poverty and against racism and Lake Source Cooling (LSC), that project that lowers the temperatures in Cornell buildings by sending heated air to be cooled in the deep, cold water of the lake. That effort was made to avoid adding pollutants into the atmosphere. This being Ithaca, LSC attracted protesters even while winning environmental awards. LSC is closely monitored by both university, governmental and community activists.

The Ithaca Farmers' Market at Steamboat Landing. *Photograph by the author.*

"ITHACA IS MY HOME"

Ulysses in The Odyssey

Ithaca is a community of communities. It contains, as Walt Whitman said (of himself), multitudes. It is a city of neighborhoods with distinctive characteristics, diverse religious organizations and political thought that spans the spectrum (from 1989 to 1995, Ithaca's mayor was a socialist). Ithaca contains numerous educational communities, from the institutions on the hills to public education and a school music and arts. Ithaca is composed of civic and improvement organizations, associations of various occupations, locations, backgrounds and interests. There are groups that aim to save whales or aid adoptive families, others that address issues of war and peace and many that bring solace to people in pain. There are booster organizations that are nationally admired, and small groups that address personal pain or grief.

The Friends of the Library began in 1946. Respected nationally and anticipated locally, it is known for its longevity, organization and contributions. The Friends supported the library through its transition from the Cornell Library (which became confusing because of the "other" Cornell Library on the hill) to its incorporation into county government, when it became the Tompkins County Public Library. The county provided a new building

Sunday at the Bethlehem Church of Jesus Christ, 702 Bishop Cecil Malone Drive, founded in 1959. *Photograph by the author.*

In 1959, the Cornell Library became the Tompkins County Public Library, relocated in 2000 on East Green Street. *Photograph by the author.*

in 1968, and when that space became too small, a public subscription in 2000, combined with aid from the Friends of the Library and county funds, created a new library in a renovated building on East Green Street that had been a Woolworth's Department Store. County residents congregate at the library, and it, too, contains multitudes of materials and people. The library is supported today by county funds, money earned from the Friends' gloriously successful annual book sales and by private donations to the Tompkins County Public Library Foundation established in 1993.

In addition to the library, there are a number of places of intersection for segments of the population. Ithacans meet at Stewart Park and at the Fourth of July fireworks, and they congregate and shop at the Farmers' Market, begun in 1973 near the inlet and now happily situated at Steamboat Landing, its permanent home on what was once the docking area for the steamboats that plied the lake.

Ithaca also has a long history of women involved with civic betterment, suffrage and activism. LUBS provided an important model of cooperation to solve acute problems. The Women's Club, begun in 1892, fostered a political study committee from which the Tompkins County Suffrage Party, and then the League of Women Voters, emerged. The Reverend Juanita Breckenridge Bates was a significant community organizer, placing her stamp on the suffrage movement of the late 1890s to 1920. Women have served on the board of education since the early years of the twentieth century. In the 1960s, inspired by the national women's movement and local discussions about women's roles, female talent nurtured community organizations, and women moved into leadership roles within city and county government. Elva Holman and Ethel Nichols were among the first women to serve on the common council. Women organized and participated in the protest movements of the 1960s and '70s, both on campus and in the community. Constance E. Cook was our assemblyperson in Albany from 1967 to 1972, during which time she addressed women's issues in general and, acting with gentleness and great courage, brought about New York's current laws governing freedom of choice. She also served as a vice president at Cornell. Peggy Haine became our local chanteuse. Alison Lurie, a nationally prominent novelist, won a Pulitzer Prize for her fiction, but she was not our only female writer. Barbara Mink served on the county board of representatives and most recently originated "Light in Winter," a January festival that brings together art, science and wonder. There were, in Ithaca, females identified by Peggy Haine as our "wild women" of the 1970s. Women also set out to chart their own way in city and county organizations, the arts and in local organizations and business. Bonnie Howard Howell became director of the Tompkins County Hospital; Audrey Edelman built a successful real estate business; Beverly Baker ran a travel agency; Peggy Williams became the fourth president of Ithaca College, ending her tenure in 2008; Judith Pastel serves as head of the Ithaca City School District; and, in 2007, Carolyn Peterson became mayor of Ithaca, reelected in 2008, bringing her gentle talents to a somewhat embroiled city hall. She also appointed the city's first female chief of police. Barbara Lifton serves as our representative in the New York State Assembly.

LOCAL CHARACTERISTICS

State and federal funds often play a significant role in local decisions. The city has responded to opportunities for funded programs, which often shape local priorities. Following the devastating flood of 1935, the state announced it would aid Ithaca with a flood abatement program. When that finally happened in the late 1950s, the inlet was straightened, with its sides established and strengthened, but much West End housing, including the Beebe Mission, disappeared. The flood control measures lessened problems created by too much water, but many consider the measures taken as having been extreme.

After years of discussion, in the 1990s, the inlet was finally spanned by new bridges, transforming an area once called the Octopus, a multi-armed intersection, into a more easily negotiated flow of traffic over two bridges—one dressed with handsome mosaics of area waterfalls (which one travels past too quickly to see) and the other with sculptures that offended many residents and caused an outcry over the issue of public taste and public art. The bridge sculptures remain, as do varied sentiments about them.

In 1988, Ithaca set about celebrating itself, exploring a sentiment from Cavafy's poem, "You must already have understood what Ithacas mean." The occasion was the centennial marking Ithaca's designation as a city. The goal in 1988 was to create a celebratory year of events that would explore Ithaca's history, introduce citizens to some of Ithaca's treasures and provide moments of feasting and communing—creating opportunities to enjoy the city. May 17 was declared the day of the "Great Ithaca Write In," an exercise that invited everyone to write an account of the day. Maxim Gorky had promoted a day of writing in 1935 as the world edged toward war; he received fifty entries. The idea was picked up a year later in China, where the goal was to "discover the face of China on one day." In 1988, Ithacans were invited to describe the day, make observations about life in Ithaca or to comment in any way that felt appropriate. Of the six thousand entries, some were in the form of poems, some drawings and one was a video. There were many from schoolchildren and others from a variety of residents. An amazing linkage occurred when Minfong Ho Dennis submitted a letter stating that her mother, Lienfung Li, had participated in the Chinese write-in in 1936. The next year, the Centennial Commission published *One Day in Ithaca: May 17, 1988* (1989), a collection of 180 personal contributions, including Lienfung Li's contribution translated from the Chinese. This project has been copied by a number of communities throughout the United States and by the State of Utah, which received half a million submissions.

The entries revealed the many faces of Ithaca. The mayor wrote about his day of meetings, beginning with a 6:45 a.m. breakfast and a 9:45 p.m. discussion with the fire chief. Other entries came from the "many Ithacas," including newcomers, doctors, storeowners and graduate students. One writer worked four blocks from his house, while others complained of the difficulties parking cars. Several wrote about illnesses they faced or their daily activities, and any number of people wrote about the complexity of their lives—their work, volunteer activities and the things they do for pure enjoyment. Many mentioned walking, watching television, their connection to others through work or play—and love. An elementary school principal worried about her staff and the world

Part of the Carl Sagan Planet Walk, stretching from the Commons to the Sciencenter, this small bridge is decorated with symbols of the planets. *Photograph by the author.*

outside the school, "filled with turmoil and confusion." A retired professor detailed his current activities as a senior citizen. One mused that "Ithaca is a city of contrasts: a small but very cosmopolitan city in a wholly bucolic setting—cosmopolitan because the reputation of Cornell University had attracted faculty and students from all over," while another complained that she did "not like Ithaca. The city is a captive of Cornell University it seems: the school determines the pay scale, the affordability and availability of housing and the social life isn't what Ithacans think it is." Today, twenty years later, some things have changed: there is better transportation around the city, linking all parts of the city to downtown and to outlying areas in a county-Cornell supported system called TCAT (Tompkins Community Area Transportation). The Octopus, that snarl of roads crossing the inlet, is only a memory.

Our relationship to the land has changed over time. Once, the lake was a working highway carrying goods and people north and south; today, it is primarily a place of recreation. Once, the water in our gorges turned mills; today, the gorges—"Ithaca is Gorges"—are hiked and appreciated for their age and beauty. Once, people made their way by foot or trolley to Ithaca's center; today, we range over the landscape. We probably appreciate the beauty of the surrounding farmland somewhat more than people did in the past. Then, it was land needed to support a family; today, we carve it into homesites and extol its beauty and isolation.

Bumper stickers: another declares that "Ithaca is Cold." *Photograph by the author.*

Ithaca has many reputations. The *Utne Reader*, in 1997, designated Ithaca "America's most enlightened city." It was also listed among "25 Terrific Places to Bring up a family" by *Mothering Magazine* (2001); offers some of the "Best fly fishing through North America" according to *Fish and Fly Magazine* (2001); is among the "60 best American public places" in *Utne Reader*; and is on the list of "Where to buy a retirement home" in *Smart Money Magazine*. It was named one of the "best places to vacation" by *Money Magazine*; one of "America's five best mountain biking towns" by *Bike Magazine*; and one of the "best Lesbian places to live: The ten Lesbian friendliest cities in the USA" by *Girlfriends Magazine*. It was called "an artist-friendly alternative to New York and Los Angeles in *The Not-so-Lost Soul Companion* (2002). In 2003, it was the "best healthy city in the Northeast" according to *Organic Style Magazine*; in 2004, it was the "Number-One emerging city," ranked in *Cities Ranked and Rated*. In 2005, it was among the "12 great places to retire" in an appraisal in *Kiplinger's Personal Finance*, and in 2006, it was the "Number-one city for knowledge workers" according to *Expansion Management Magazine*. Ithaca was ranked among the seventeen "best places for business and careers" by *Forbes Magazine* and one of the twelve "Great places you've never heard of" by *Mother Earth News Magazine*. In 2008, *Country Home Magazine* rated Ithaca the "Greenest City" in the nation, and *Outside Magazine* rated Ithaca one of the ten towns working toward "progressive change"—Ithaca's thirtieth mention in a top-town list since 1997. All of this is certainly "*so* Ithaca."

At the same time, many people have observed that "Ithaca is a hard community to enter." They find their way only slowly into community organizations or employment. More so than elsewhere? I don't know. In Ithaca, people discover that houses are generally known by the names of their previous owners—the Crandall House, the Bouton House. They find that, while there is wealth in the community, there is also great need. They discover that costs are high. "You know Ithaca is getting too expensive," wrote a contributor to the *Ithaca Times* in September 2007, "when rent is higher than most mortgages in the surrounding six counties."

This is still a transient community—the "most fluctuating place," said a writer back in the 1830s. According to the U.S. Census, only 19.4 percent of Ithacans lived in the same house for five or more years. So many people who live in Ithaca know only their own route through the community, but not where Southside is. Many who live here do not care to know about the names of streets or the history of those who once lived here. They do not know the ghosts whose houses they inhabit, nor do they wonder about who first planted their garden or how the past played out on this canvas. Ithacans are present-minded, goal-oriented, ecological, granola-eating, tree-hugging folks in Birkenstocks—some of them. Some people live in an occupational world and could be located anywhere, a fact that is even more possible in the age of the Internet. Others walk the streets, poke about, meet those who come along and appreciate the ease of life here. They join a committee, speak out about changes they dislike and they would be nowhere else. This is a good place to raise children and a fine place for cultural events, from classical music to bluegrass, doo-wop and hip-hop, and from street art to the print shop. It is a place of community activities and activism, an enlightened small city. Ithaca's children grow up with appreciation of place, but most need to go elsewhere to find work, for opportunities here, while limitless, are also finite.

AN ITHACA YEAR

College towns are currently enjoying a new popularity. They lure us with the promise of the future. They are the places of preparation, where our children and grandchildren encounter dorms and deans, classes, nights in the library and even later nights in fraternity houses smelling of brothers of long ago. College towns are full of portent. They are places where the young begin to separate from their elders to emerge with skills we could never have dreamed of. There they are, young lawyers and businessmen, engineers and doctors. But college towns are also about the past. They tug at memory. They are where we were young.

College towns have common features. There is the library into which young people disappear, cafés and bookstores, shops that sell clothing labeled with a giant letters: IC or CU. There are bars and movie houses. There are faculty enclaves and homes where the townies live. Sometimes these overlap. There are bells that chime out over the landscape and shouts from crowds on Saturday afternoons. Ithaca is like no other college town, just as Cornell University is unlike other institutions of higher learning, for Cornell began as a university in a country of colleges. Ithaca had to grow into its role. Over the

A view from South Hill, after Henry Walton's 1838 rendition. *Used with the kind permission of the artist, Lucy Bergstrom.*

years, the university protected Ithaca from national economic troubles, providing steady employment, drawing faculty and students and maintaining the community as it grew. But Ithaca remained stubbornly small-town, even shabby at times.

A college town runs on academic time. The year begins in August, when rental trucks bring newcomers, and it ends in June. Ithacans breathe a bit more easily in the summer months, when there are more parking spaces. The year propels itself forward as the local calm of summer is broken by the return of students. They come in cars and vans, on planes and buses; a few walk up the hill. Once assembled, their presence creates a hum of energy, and they take up space—restaurants, movie lines and the grocery stores grow busier. New people come to Ithaca in August, too, moving into houses or apartments, finding their way about. Their children make friends and their dogs test out the neighborhood.

The momentum of the academic year pulses forward. September is a time to make promises to shape up, think about better grades or learn the subjunctive. We plant in autumn in anticipation for the spring. We walk in the autumn woods, knowing that by winter there will be only a cool glimmer of light. Recently, Halloween has taken on a new importance; it is more visible and continues for a longer time than in the past. It is more commercial, too, with store-bought lawn ornaments and costumes that come out of a bag. Thanksgiving is as much a signal to shop, as it is a time to reflect on our blessings. Both things happen, of course, but there is a headlong rush after Thanksgiving that seems to be propelled from without rather than from a personal urge to get ready for the holiday. It is not for Christmas any longer, but "the Holidays," including Hanukah and Kwanzaa. Winter hovers in the background. It has been known to arrive in October or wait until the New Year, and we dangle in anticipation.

As the weather darkens, Ithaca retreats into itself. The Iroquois who once lived here divided their year into times when crops came in—strawberries, tobacco, squash and corn—and the starving time during the winter, when clan mothers conserved food in order to get through until maple sugar time in the spring. Our winter might be called a hunkering-down time. Today, we conquer winter with automobiles, electricity and home heating, but it still is a time when there is coughing in the library and one grows weary of boots. Spring comes late to Ithaca. E.B. White thought spring was "recalcitrant" in the Lake Country, not dependable until mid-April, when suddenly there is a rush of gold, daffodils and forsythia, that gives way to lavenders, pinks and blue.

Then, as suddenly as they came in September, the students depart, leaving the city to assume its own, more natural pace. There are plants for sale, and the birds sing for their new nesting year. Flowers blossom, the rains come and there is the reward of summer, when life at the head of the lake softens and the days lengthen into sunsets that make us gaze in amazement. Summer in Ithaca is for many the reward for surviving the winter; it is the time when indoor cats insist upon going outside and we join them to sigh at our good fortune. All this, until it is late August and the cycle of the academic year begins again.

Ours is a year dependent on educational institutions, but, of course, the courts, the hospital, merchants and industry continue year-round. Ours is a community heightened by the intensity of the weather, a year that is marked by the cycles of life that swing us forward with anticipation of beauty that unexpectedly appears—trees setting new leaves, the magnolias on North Tioga Street or an explosion of flowers at street corners.

A view taken from West Hill, after Henry Walton's 1839 lithograph. *Used with the kind permission of the artist, Lucy Bergstrom.*

Who put these here, we wonder? We are marked, too, by the landscape—the descending notes of water running over rocks in Cascadilla Creek; the wildflower trails into Six Mile Creek; the walk along the inlet, where water birds gather and out on the water there is a kayak moving silently along. We know that outside the window there is always something to see.

Ithaca is not, however, Brigadoon isolated from the problems of the world. Ithacans take their relationship to causes seriously. The things that bind Ithacans into a community do not shield them from their sometimes-awkward differences. There is a chasm between the best and worst paid, even though the Alternatives Credit Union has long advocated for a living wage. There are religious differences. There are the very well educated, who sometimes seem to live in a national world of academe rather than in Tompkins County, and there are those desperately in need of education and the possibilities of betterment that it can bring. Ithacans are tremendously creative folk. I was once told that at any one time there were more than thirty people writing plays in Ithaca, and that *everyone*—that exaggeration is *so* Ithaca—is writing a book or had written one, is chairing a committee or volunteering for one, is protesting something in front of the post office or on the Commons. Still, there is a hesitation to embrace the local, the homemade, in fear, I think, of being perceived as provincial or small-town. An author published by a national press who wins a national award is more likely to receive local recognition than the fine poet working away in a small room matching words to ideas.

Amid all the conversation that goes on in Ithaca, there is a wariness in our discussions of race. Most of us understand the wrongs of the past and seek ways of shaping a positive community response. There are some who cannot see beyond racial injustice to recognize the open hands reaching in their direction. The community discussion about race ebbs and then erupts. There is a desire to create a more just world and a belief that problems created by racial divides can be solved. There is a belief in democratic participation, even when that does not always occur. There are "social activists" in Ithaca, both black and white, who "get involved and volunteer to bring about social change." Every issue of division is not based on "racism," for here, as elsewhere, differences in class often determine opportunity. We need to use race, counsels Gino Bush, a black activist, as "an educational tool" rather than as a club against each other.

The relationship between town and gown is also sometimes awkward. Ithacans were excited to have a university sited on East Hill, but they became wary about newcomers and the changes they caused. Even so, Ithacans attend concerts, lectures and theatre on the hills and root for collegiate athletic teams. Ithacans have graduated from Cornell University and Ithaca College, and many have remained to live here, or returned here for what they would say is an extraordinary "quality of life." The university, needing to expand, has clashed with the city's desire to control growth. Parking has caused difficulties between the hills and the flats. Yet, over the past decade, there has been visible town-gown cooperation, and since 1995, with an agreement signed between the university trustees and the City of Ithaca, the university has contributed financially to the school district and to the city, seeking cooperative answers to their intertwined problems. In welcoming the new president of Ithaca College in 2008, an *Ithaca Journal* editorial commented that, in Ithaca, "town-gown relations are always at the forefront of any community discussion."

So ITHACA

So Ithaca. That is the aspect of community life that tends to over-do, over-organize, over-expound and to think that everyone should adopt one's point of view. Instantly, if I don't write it first, someone will say that, in truth, there is no one Ithaca opinion about anything, and that is *so* Ithaca, too. It is *so* Ithaca to be running to a committee meeting on civic improvement, carrying a political sign while wearing gym clothes and drinking a *Gimme!* coffee. It is *so* Ithaca to think this a paradise, while still petitioning to save the Clinton House, the gorge, the redbuds, the whales, the world and to bring better films to town. It is *so* Ithaca to live in this small city and yet to somehow expect the cultural range of a large metropolis—and to often have that expectation met.

For all its turmoil, its long endless dialogues about growth and change, its "*so* Ithaca" moments, Ithaca gets under the skin and marks one for life. One need not adopt Birkenstocks or eat granola at breakfast. Real Ithacans, said a woman quoted in the *Ithaca Times* in 2007, are "always late, never at fault, and are trying really hard to get better but struggling with some personal stuff. They have a protest sign. They have a tattoo. They have a favorite waterfall. A cloth grocery bag…[they] still remember Cabbage Town and Clever Hans." A "real Ithacan" is someone like Paul Glover, a community activist, who has placed his unique stamp on the city, but has since moved elsewhere. Glover promoted an effective online community newsletter, and in 1991 he innovated a local currency scheme that advocates economic strength by promoting social justice, ecology and community participation by circulating local money, called "Ithaca Hours," to build the local economy. Noticed by the national press, over $100,000 is now in circulation locally, and there are over nine hundred participants who accept Ithaca Hours for goods and services. That is *so* Ithaca.

We characterize Ithaca all the time, leaning on its past to craft a definition. It is "ten square miles surrounded by reality," while in truth Ithaca is only 5.5 square miles, surrounded by the Town of Ithaca. And here, too, is an oddity: Ithaca is called "town" and has a "downtown," but while it has been a village and a city, it has never been a town. Howard Cogan wrote "Ithaca is Gorges," a slogan he might have placed under a copyright but never did so it belongs in the public domain. That is *so* Ithaca. Larry Baum, president of the Ithaca Air Service Board, defined Ithaca in 2008, when a third airline announced it would serve our airport as a place with many "international travelers" with "a relatively stable economy and the large student population." It is also *so* Ithaca that when advertising for a new director of planning, the announcement on the front page of the *Ithaca Journal* (July 1, 2008) stated that the ideal candidate should be someone who is "aware of the uniqueness and diversity of Ithaca." A person who is "very concerned about the environment and global warming and those kinds of things. And somebody who's interested in making this community more bike/walk/alternative-forms-of-transportation friendly." A member of Ithaca's common council added that the three guiding principles for the director should be "conservation and planning, social and economic justice and planning, and incorporation of the public" in the process. Now, that is *so* Ithaca.

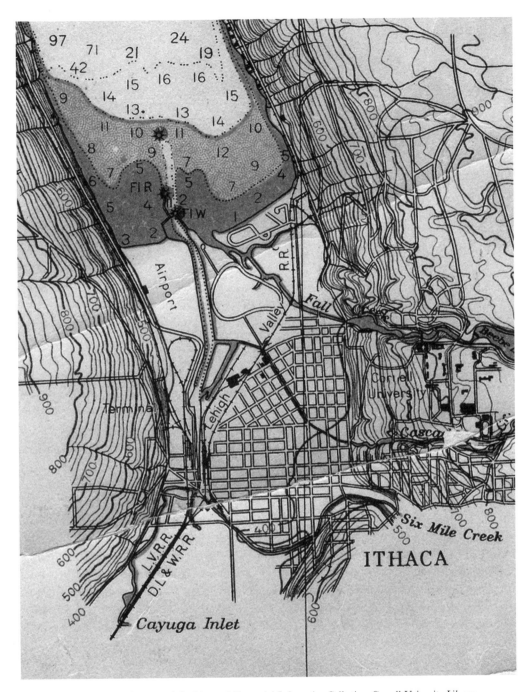

A 1940s nautical map. *Courtesy of the Map and Geospatial Information Collection, Cornell University Library.*

ITHACA

A view taken from East Hill (1988), after Henry Walton. *Used with the kind permission of the artist, Lucy Bergstrom.*

Ithaca is an imperfect place, both sweet and sour like the cherries sold in June. Throughout time, it has maintained its character, even while there has been a homogenization of many American towns. Ithaca's history is one of unrealistic optimism and some failure—but weren't we lucky in 1841, when the only industry that showed any interest in relocating was a bleach works that would have built on Fall Creek, ruining Ithaca Falls with its runoff. What was seen as a failed venture for Ezra Cornell that year turned out to have been in Ithaca's best interest. Ithaca's past has been punctuated by challenges presented by the city's setting, by the fluctuations of the times and by national events. But Ithaca has been fortunate in those who have cared about the future. While there is always something to improve in Ithaca, and usually a committee discussion about how that may be done, it is also a city that sears our hearts. To be away from Ithaca is to long for it; to be here is to be home.

"Welcome to another day in paradise."

BIBLIOGRAPHY

Abt, Henry Edward. *Ithaca*. Ithaca: Ross W. Kellogg, 1926.

Architectural Heritage of Tompkins County. Ithaca: Office of the Tompkins County Historian, Historic Ithaca, and the DeWitt Historical Society, 2002.

Becker, Carl L. *Cornell University: Founders and the Founding*. Ithaca: Cornell University Press, 1943.

Bishop, Morris. *A History of Cornell*. Ithaca: Cornell University Press, 1962.

Burns, Thomas W. *Initial Ithacans*. Ithaca: Press of the Ithaca Journal, 1904.

Burritt, D.C. *Methodism in Ithaca. A History*. Ithaca: Andrus, Gauntlett & Co., 1852.

Cross, Whitney R. *The Burned-Over District: The Social and Intellectual History of Enthusiastic Religion in Western New York, 1800–1850*. Ithaca: Cornell University Press, 1950.

Dedication of the Cornell Library Building. Ithaca, NY, December 20, 1866. New York: American Photo-Lithographic Co., 1867.

Dieckmann, Jane M. *A Short History of Tompkins County*. Ithaca: DeWitt Historical Society, 1986.

Eisenstadt, Peter, ed. *Encyclopedia of New York State*. Syracuse: Syracuse University Press, 2005.

Hesch, Merrill, and Richard Peiper. *Ithaca Then and Now*. Ithaca: McBooks, 1983.

History of the DeWitt Guard, Company A. Ithaca: Andrus, McChain & Co., 1866.

History of the First Presbyterian Church of Ithaca, New York. Ithaca, Andrus and Church, 1904.

History of Tioga, Chemung, Tompkins and Schuyler Counties New York. Phildelphia: Everts & Ensign, 1879.

Ithaca Chronicle

Ithaca: Chronological Historical Events. A supplement to Manning's *Ithaca Directory*. N.p., 1939.

Ithaca Democrat

Ithaca Journal

Ithaca Journal Centennial Number, 1915

Ithaca Times

Kammen, Carol. *Cornell University: Glorious to View*. Ithaca: Cornell University Library, 2003.

———. *First Person Cornell: Students' diaries, letters, email, and blogs*. Ithaca: Cornell University Library, 2006.

———. *Lives Passed*. Interlaken: Heart of the Lakes Publishing, 1984.

———. *Peopling of Tompkins County: A Social History*. Interlaken, Heart of the Lakes Publishing, 1985.

———. *What they Wrote: 19th Century documents from Tompkins County, New York*. Ithaca: Cornell University, Department of Manuscripts and University Archives, 1978.

Kammen, Carol, ed. *Place Names of Tompkins County*. Ithaca: Office of the Tompkins County Historian, 2004.

King, Horace. *Early History of Ithaca*. Ithaca: n.p., 1847.

Klein, Milton M., ed. *The Empire State: A History of New York*. Ithaca: Cornell University Press, 2001.

Lee, Hardy Campbell. *A History of Railroads in Tompkins County*. Revised, expanded edition by Winton Rossiter. Ithaca: DeWitt Historical Society, 1977.

Mayer, Virginia W. *Ithaca Past and Present*. Ithaca: City School District, 1956.

O'Daniel, Janet. *The Cliff Hangers: A Novel*. Philadelphia: J.B. Lippincott, 1961.

Scenery of Ithaca and the Headwaters of the Cayuga Lake. Ithaca: Spence Spencer, 1866.

Selkreg, John H. *Landmarks of Tompkins County*. Syracuse: D. Mason, 1894.

Sernett, Milton C. *North Star Country: Upstate New York and the Crusade for African American Freedom*. Syracuse: Syracuse University Press, 2001.

Sisler, Carol U. *Enterprising Families, Ithaca, New York: Their Houses and Businesses*. Ithaca: Enterprise Publishing, 1986.

Sisler, Carol U., et al., eds. *Ithaca's Neighborhoods: The Rhine, the Hill, and the Goose Pasture*. Ithaca: DeWitt Historical Society, 1988.

Snodderly, Daniel R. *Ithaca and Its Past*. Revised edition. Ithaca: DeWitt Historical Society,1984.

Southwick, Solomon. *Views of Ithaca and Its Environs by an Impartial Observer*. Ithaca: n.p., 1935.

United States Census Office. 1790–2000.

Wellman, Judith. *Grass Roots Reform in the Burned-Over District of Upstate New York: Religion, Abolitionism, and Democracy*. New York: Garland Publishing, 2000.

White, Grace Miller. *The Ghost of Glen Gorge*. New York: Macaulay Company, 1925.

———. *Secret of the Storm Country*. New York: Grosset & Dunlap, 1916.

———. *The Shadow of the Sheltering Pines*. New York: Gosset & Dunlap, 1919.

———. *Storm Country Polly*. Boston: Little, Brown, and Company, 1920.

———. *Tess of the Storm Country*. New York: Grosset & Dunlap, 1909.

Wisner, William. *A Half Century Sermon*. Ithaca: n.p., 1866.

———. *A Narrative of the Revival of Religion in Ithaca*. 1827.

INDEX